CW01374274

Graphis Inc. is committed to celebrating exceptional work in Design, Advertising, Photography & Art/Illustration internationally.

Published by **Graphis** | Publisher & Creative Director: **B. Martin Pedersen** | Designer: **Hee Ra Kim** | Associate Designer: **Hie Won Sohn**
Associate Editor: **Angela Sabarese** | Assistant Editor: **Stefanie Feldman** | Administrative Assistant: **Patricia Cordero**

Graphis Poster Annual 2019

Published by:
Graphis Inc.
389 Fifth Avenue, New York, NY 10016
Phone: 212-532-9387
www.graphis.com
help@graphis.com

Distributed by:
National Book Networks, Inc.
15200 NBN Way, Blue Ridge Summit, PA 17214
Toll Free (U.S.): 800-462-6420
Toll Free Fax (U.S.): 800-338-4550
Email orders or Inquires: customercare@nbnbooks.com

Legal Counsel: John M. Roth
3140 Bryant Avenue South, #3, Minneapolis, MN 55408
Phone: 612-360-4054
johnrothattorney@gmail.com

ISBN 13: 978-1-931241-69-4
ISBN 10: 1-931241-69-4

This book contains some logos that were designed by students for mock clients for the purpose of completing classroom assignments. All trademarks and logos depicted in this book belong solely to the owners of the trademarks and logos. By using the trademarks and logos in these student projects, neither the schools nor the faculty and students intend to imply any sponsorship, affiliation, endorsement or other association with the trademark and logo owners. The student projects were executed strictly for noncommercial, educational purposes.

The students whose work includes the logo or trademark of a company or corporation in this book clearly have passion for that company. Graphis would therefore encourage the ad agencies that have these accounts to perhaps connect directly with these students, and to seriously consider employing them.

We extend our heartfelt thanks to the international contributors who have made it possible to publish a wide spectrum of the best work in Design, Advertising, Photography, and Art/Illustration. Anyone is welcome to submit work at www.graphis.com.

Copyright © 2018 Graphis, Inc. All rights reserved.
Jacket and book design copyright © 2018 by Graphis, Inc.
No part of this book may be reproduced, utilized or transmitted in any form without written permission of the publisher. Printed in China.

UMBERTO ECO

HOMAGE TO

Contents

List of Poster Museums	7	Corporate	46	Museum	94	Typography	151
New Talent Annual 2018		Education	48	Music	98	**Silver Awards**	**155**
Platinum Award-winning Works	8	Entertainment	52	Opera	103	Honorable Mentions	199
Competition Judges	13	Environment	58	Promotion	107	Credits & Commentary	216
Platinum Awards	**23**	Events	60	Public & Social Services	114	Index	227
Platinum Winners	24	Exhibits	73	Publishing	117	Winners Directory	230
Gold Awards	**37**	Festivals	83	Real Estate	118	Winners by Country	233
Automotive	38	Food & Beverage	90	Social & Political	125	Graphis Titles	238
Beauty & Fashion	40	Lectures	92	Sports	141		
Commemorative	41	Medical	93	Theater	142		

Page 3: *"João Package Machado Design"* designed by João Machado
Page 4: *"Homage to Umberto Eco"* designed by Rikke Hansen

CRITERIA USED TO CHOOSE POSTERS FOR THE COOPER HEWITT MUSEUMS:

Decisions about the museum's permanent collection are made with careful deliberation.

A curator must prepare a written justification, which is presented to a committee consisting of curators, trustees, conservators, and the museum's director.

Criteria include the condition of the piece, its aesthetic quality or significance, the likelihood that the museum will exhibit the work, its value to scholars, and its relevance to the overall collection.

Sometimes a piece represents a unique production method or an important artistic movement. Sometimes it is related to a planned exhibition or book.

Ellen Lupton, *Poster Annual 2017, Senior Curator, Cooper Hewitt Smithsonian Design Museum*

7 LIST OF POSTER MUSEUMS

THE AMERICAS

Asian Art Museum
www.asianart.org
200 Larkin St.
San Francisco, CA 94102
United States
Tel 415 581 3500

**Center for the Study
of Political Graphics**
www.politicalgraphics.org
3916 Sepulveda Blvd., Suite 103
Culver City, CA 90230
United States
Tel 310 397 3100

Chicago Design Museum
www.chidm.com
Block Thirty Seven
108 N State St., 3rd Flr.
Chicago, IL 60602
United States
Tel 312 894 6263

Cleveland Museum of Art
www.clevelandart.org
1111 East Blvd.
Cleveland, OH 44106
United States
Tel 216 421 7350

Cooper Hewitt
www.cooperhewitt.org
2 E. 91st St.
New York, NY 10128
United States
Tel 212 849 8400

The Los Angeles County Museum of Art
www.lacma.org
5905 Wilshire Blvd.
Los Angeles, CA 90036
United States
Tel 323 857-6000

The Metropolitan Museum of Art
www.metmuseum.org
1000 5th Ave.
New York, NY 10028
United States
Tel 212 535 7710

Minneapolis Museum of Art
www.new.artsmia.org
2400 Third Avenue South
Minneapolis, MN 55404
United States
Tel 612 870 3000

Museum of Arts and Design
www.madmuseum.org
Jerome and Simona Chazen Building
2 Columbus Circle
New York, NY 10019
United States
Tel 212 299 7777

Museum of the City of New York
www.mcny.org
1220 Fifth Avenue (at 103rd Street)
New York, NY 10029
United States
Tel 212 534 1672

Norman Rockwell Museum
www.nrm.org
9 Glendale Road
Route 183
P.O. Box 308
Stockbridge, MA 01262
United States
Tel 413 298 4100

North Carolina Museum of Art
www.ncartmuseum.org
2110 Blue Ridge Rd.
Raleigh, NC 27607
Tel 919 839 6262

Oakland Museum of California
1000 Oak St.
Oakland, CA 94607
United States
Tel 510 318 8400

Saint Louis Art Museum
www.slam.org
One Fine Arts Drive
Forest Park
St. Louis, MO 63110-1380
United States
Tel 314 721 0072

The Seattle Art Museum
www.seattleartmuseum.org
1300 First Avenue
Seattle, WA 98101
United States
Tel 206 654 3100

The Taft Museum of Art
www.taftmuseum.org
316 Pike St.
Cincinnati, OH 45202
United States
Tel 513 241-0343

U.S. Navy Poster Museum
411 Main St.
Point Pleasant, WV 25550
United States
Tel 304 675 4989

Walker Art Museum
www.walkerart.org
1750 Hennepin Ave.
Minneapolis, MN 55403
United States
Tel 612 375 7600

EUROPE AND AFRICA

Bauhaus Archives (Bauhaus-Archiv)
www.bauhaus.de
Klingelhöferstraße 14
10785 Berlin
Germany
Tel +49 30 2540020

The Berardo Collection Museum
www.berardocollection.com
Praça do Império
1449-003 Lisboa
Portugal
Tel +351 21 361 2878

Dansk Plakatmuseum
www.plakatmuseum.dk
Viborgvej 2
8000 Aarhus
Denmark
Tel +45 86 15 33 45

Designmuseum Danmark
www.designmuseum.dk
Bredgade 68
1260 Kobenhavn
Denmark
Tel +45 33 18 56 56

Design Museum
www.designmuseum.org
28 Shad Thames
London SE1 2YD
United Kingdom
Tel +44 20 7403 6933

Deutsches Plakat Museum
www.museum-folkwang.de
Museumsplatz 1
45128 Essen
Germany
Tel +49 201 884 51 08

Galeria Plakatu - Poster Gallery
www.cracowpostergallery.com
31-043 Kraków
Kramy Dominikańskie
ul. Stolarska 8-10
Poland
Tel +48 12 421 26 40

Kunsthalle Basel
www.kunsthallebasel.ch
Steinenberg 7
CH-4001 Basel
Switzerland
Tel +41 61 206 99 00

Lahti Art Museum
www.lahdenmuseot.fi
Vesijärvenkatu 11 A
Box 113
FIN-15111 Lahti
Finland
Tel +358 3 814 4547

**MAK Austrian Museum
of Applied Arts/Contemporary Art**
www.mak.at
Stubenring 5
1010 Wien
Austria
Tel +43 1 711360

Moderna Museet (Malmö)
www.modernamuseet.se
Ola Billgrens plats 2-4
SE-211 29 Malmö
Sweden
Tel +46 40 685 79 37

Moscow Design Museum
www.moscowdesignmuseum.ru
125009, Moscow
Manege Square, 1
Russia
Tel +7 495 991 90 42

**MUSAC - Museo de Arte
Contemporáneo de Castilla y León**
www.musac.es
Avenida Reyes Leoneses
24 24008 León
Spain
Tel +34 987 09 00 00

Museum Boijmans
www.boijmans.nl
Museumpark 18
3015 CX Rotterdam
The Netherlands
Tel +31 10 441 9400

Museum Fur Gestaltung
www.museum-gestaltung.ch
Toni-Areal, Pfingstweidstrasse 96
CH-8005 Zürich
Switzerland
Tel +41 43 446 67 67

Museum Haus Konstruktiv
www.hauskonstruktiv.ch
Selnaustrasse 25
CH-8001 Zürich
Switzerland
Tel +41 44 217 70 80

Museo d'Orsay
www.musee-orsay.fr
62, rue de Lille
75343 Paris Cedex 07
France
Tel +33 (0)1 40 49 48 14

Pinakothek Der Moderne
www.pinakothek.de
Barer Straße 29
80333 Müenchen
Germany
Tel +49 89 23805360

Poster Museum at Wilanów
www.postermuseum.pl
St. Kostki Potockiego 10/16 Street
PL 02-958 Warsaw
Poland
Tel +48 22 842 26 06

Stedelijk Museum Amsterdam
www.stedelijk.nl
Museumplein 10, 1071 DJ
Amsterdam
Netherlands
Tel +31 (0)20 5732 911

Stedelijk Museum Breda
stedelijkmuseumbreda.nl
Boschstraat 22, 4811 GH
The Netherlands
T 076 – 529 99 00
info@stedelijkmuseumbreda.nl

Swiss Poster Museum
www.swisspostermuseum.com
Manessestrasse 170
CH-8045 Zürich
Switzerland
Tel +41 (0)78 750 77 07

Tate Modern (London)
www.tate.org.uk
Bankside
London SE1 9TG
United Kingdom
Tel +44 20 7887 8888

Triennale di Milano
www.triennale.org
Viale Alemagna, 6
2012 Milano
Italy
Tel +39 02 724341

Victoria and Albert Museum
www.vam.ac.uk
Cromwell Road
London SW7 2RL
United Kingdom
Tel +44 020 7942 2000

ASIA AND OCEANIA

Mori Art Museum
www.mori.art.museum
53F Roppongi Hills Mori Tower,
6-10-1 Roppongi
Minato-ku, Tokyo
Japan
Tel +81 3 5777 8600

**Museum of Contemporary
Art Australia**
www.mca.com.au
140 George St.
The Rocks NSW 2000
Australia
Tel +61 2 9245 2400

**Shanghai Propaganda
Poster Art Center**
www.shangaipropandaandart.com
868 Huashan Road
Xuhui, Shanghai
China
Tel +86 21 6211 1845

Additional Museums:
*If you are a museum that collects
poster and are not listed above, please
contact us for inclusion in our
next Annual at help@graphis.com.*

NEW TALENT ANNUAL 2018 PLATINUM AWARD-WINNING POSTER DESIGN INSTRUCTOR & STUDENT WORK:

Dong-Joo Park, Seung-Min Han
Hansung University of Design & Art Institute

Sean Adams, Chris Hacker
Art Center College of Design

Eileen Hedy Schultz
School of Visual Arts

Tyler Hopf
School of Visual Arts

Instructors Dong-Joo Park, Seung-Min Han | Student: Dan Bi Kim | Exhibition trucks, Artourist

10 ART CENTER COLLEGE OF DESIGN **PLATINUM**

CATERPILLAR

CATERPILLAR

Instructors Sean Adams, Chris Hacker | Student: Moonyong Ro | Caterpillar posters and an annual report

11 SCHOOL OF VISUAL ARTS **PLATINUM**

DESIGN COMPETITION
Deadline: December 17
Type Directors Club
347 West 36th Street
New York, NY 10018
www.tdc.org

Instructor Eileen Hedy Schultz | Student: Sean Dong | Type Poster

12 SCHOOL OF VISUAL ARTS PLATINUM

I BEHELD THE PROTECTOR, NEVER DESCENDING, GOING BY HIS PATHS TO THE EAST AND THE WEST;

CLOTHING THE QUARTERS OF THE HEAVEN AND THE INTERMEDIATE SPACES.

HE CONSTANTLY REVOLVES IN THE MIDST OF THE WORLDS.

"MAYA"
A VIRTUAL REALITY EXPERIENCE
DIRECTED BY BEN CONE

Instructor Tyler Hopf | Student: Joe Haddad | Maya Poster

Graphis Judges

14 POSTER ANNUAL 2019 COMPETITION JUDGES

Fons Hickmann | Designer, Author & Professor | Fons Hickmann m23 | www.fonshickmann.com
Biography: Fons Hickmann is a graphic designer, author, and professor of design at the University of Arts in Berlin. In 2001, he founded the influential design studio "Fons Hickmann m23." The studio focuses on the design of complex communication systems and works mainly in the cultural field, ranking among today's most awarded design studios worldwide. The studio lends its expertise to everything related to events, communication, and visual identity. ■ Hickmann has taught at several universities, held lectures and workshops around the world, and is a member of TDC New York, ADC and the Alliance Graphique International. Increasingly, he is dedicating himself to the publication of literature on diverse fields of knowledge from design through media theory to football and pop culture.
Commentary: It was an honor to be part of this year's jury. I first got to know Graphis as a student, when it was still a Swiss design magazine. Even then, Graphis was already known for representing the best graphic design in the world. The traditionally European magazine flourished in New York, which resulted in some great publications. ■ I was very impressed with the quality of the entries this year. There were many unique points of view and a lot of creativity. One trend I noticed was the return of the minimalist, intelligent poster. The discipline of poster design is constantly evolving and is, to me, still the pinnacle of graphic design: it is often more related to art than to advertising and always pushing boundaries.

Andrew Hoyne | Principal | Hoyne | www.hoyne.com.au
Biography: Andrew is the Principal of brand agency Hoyne. They're a firm of 75 people and they've been in business for 27 years. As a leader in brand creation, Andrew has created the drum logo for Triple J, designed stamps for Australia Post, created a leading beer brand in Pure Blonde, rejuvenated heartland food and beverage brands from Vegemite to Peter Lehmann Wines and rebranded Hudsons and Snooze. ■ In recent years Hoyne has evolved their service offer, working closely with developers, government, and councils with a core focus in place and property. They help to create recognisable landmarks across Australia. Andrew's belief that we can do more to create meaningful places led him to publish The Place Economy, a 400-page resource book that presents thought-leadership on best practice placemaking from around the world. It shows that investment in better places leads to greater profit for developers and investors, and results in economies that perform better and communities that are happier and healthier. ■ Last year Andy spoke at over 20 local and international conferences and events. ■ Volume 2 of The Place Economy is expected to be even more momentous, and will be released later this year.
Commentary: The pieces of work which resonated with me were simple, ideas-driven design solutions. I appreciated the bold, dynamic graphic impact of other successful works, particularly in the context of the medium being a poster. Some of the best examples of that were in the entertainment category. Uniquely crafted typographic and illustrative solutions were a joy to view. A number of great ones featured cars or motorbikes, so had I been looking at these with male tinted glasses? No, as several others I really liked featured more feminine patterns, so gender bias played no role. Ultimately, the most powerful was a political poster, in an age where the rest of the world will never view the USA the same again with relation to Trump and gun control.

Zach Minnich | Communication Artist | Thirst | www.3st.com
Biography: Zach Minnich is a communication artist currently engaged as a designer at Thirst. Originally from Dayton, Ohio, he received his BFA in Graphic Design from Bowling Green State University in 2014. Minnich is forging a lifetime of practice and describes the on-going work as a search for his voice through a collection of studies.
Commentary: It was an honor to be selected as a judge for this year's poster competition and a joy to review such a vast range of work from so many different industries. The amount of compelling work is almost overwhelming, and I hope that my contribution to this year's show will inspire those to keep pushing the needle a little further.

Rick Valicenti | Founder & Design Director | Thirst | www.3st.com
Biography: Rick Valicenti is the founder and design director of Thirst, a communication design practice providing design and immersive environments for high profile clients in the architectural, performing arts, and education communities. The White House honored Valicenti in 2011 with the Smithsonian Cooper Hewitt, National Design Award for Communication Design. In 2006, he received the AIGA (American Institute of Graphic Arts) Medal, the highest honor of the graphic design profession, for his sustained contribution to design excellence and the development ofthe profession. In 2004, he was recognized as a Fellow of the AIGA Chicago. He has served on the Art Institute of Chicago's Architecture & Design Society under curator Zoe Ryan since 2011. Valicenti is currently leading a Moving Design initiative on fresh air in Beijing, China. Entitled "Deep Breath," the three-year project involves 20 interdisciplinary design students. Their work exhibited at the Salone de Mobile Milano in 2014.
Commentary: Throughout time, the poster has stood as an enduring reflection of the moment it was designed. This year's Graphis archive is no exception, for it too will certainly serve the future practitioner as a record of the early 21st century poster. In this collection of design excellence, the best traditions of the past are present as they stand alongside an optimistic hint of the future.

Daeki Shim | Designer & Co-founder | DAEKI&JUN | www.daekiandjun.com
Biography: Daeki Shim is a Seoul-based graphic designer and co-founder of the DAEKI & JUN design studio. He received a bachelor's degree in graphic design from Central Saint Martins, University of the Arts London and a master degree from University College London (UCL), University of London. In addition to carrying out commissioned projects, he currently lectures through the Design Innovation Department at Sejong University and works as an adjunct professor in the Visual Communication Design Program at Seoul National University of Science & Technology. DAEKI & JUN's designs have been recognized by more than 80 international design awards around the world. The latest awards are the Grand Prix of Red Dot Award in 2017 and the Graphis Poster Annual Gold Award in 2017 & 2016 and Grand Prize of the Exhibition of the Korean Society of Typography in 2015 & 2016.
Commentary: It was a great experience to look at several good works deeply and carefully.

Hyojun Shim | Designer & Co-founder | DAEKI&JUN | www.daekiandjun.com
Biography: Hyojun Shim is a Seoul-based graphic designer and co-founder of the DAEKI & JUN design studio. He received a bachelor's degree in graphic design from Central Saint Martins, University of the Arts London, a master degree from Goldsmiths, and another master degree from University College London (UCL), University of London. In addition to carrying out commissioned projects, he currently lectures at Universities. DAEKI & JUN's designs have been recognized by more than 80 international design awards around the world. The latest awards are the Grand Prix of Red Dot Award in 2017 and the Graphis Poster Annual Gold Award in 2017 & 2016 and Grand Prize of the Exhibition of the Korean Society of Typography in 2015 & 2016. He was also the organizer and curator of several design exhibitions in London, and now is preparing a Book Club-CENTER 2 CENTER, a new publishing project with Daeki Shim.
Commentary: There were a lot of great works so it was difficult to evaluate at times. However, evaluating the work of other designers was a new and fulfilling experience.

As judges Fons Hickmann, Andrew Hoyne, Daeki Shim, and Hyojun Shim were also entrants and winners, special care was taken to insure that they did not judge their own work.

15 POSTER ANNUAL 2019 JUDGE FONS HICKMANN

this way please | Bureau for social development | Fons Hickmann m23

16 POSTER ANNUAL 2019 JUDGE **FONS HICKMANN**

Orlando | Semper Opera | Fons Hickmann m23

17 POSTER ANNUAL 2019 JUDGE ANDREW HOYNE

猴年大吉
**HAPPY CHINESE
NEW YEAR 2016
YEAR OF THE MONKEY**

Hoyne.© 2016

Chinese New Year 2016 | Self-initiated | Hoyne

18 POSTER ANNUAL 2019 JUDGES ZACH MINNICH, RICK VALICENTI

2005–2006 poster generously sponsored by **WINSTON & STRAWN**

Untitled | Lyric Opera of Chicago | Thirst

19 POSTER ANNUAL 2019 JUDGES ZACH MINNICH, RICK VALICENTI

IN Light IN / Indianapolis Light Festival / 26-27 August 2016
Central Indiana Community Foundation / Efroymson Family Fund / cicf.org

IN Light IN | Central Indiana Community Foundation | Thirst

Landscapes, unlike their representations, are constituted in space-time. They are always changing, in the process of being and becoming, never exactly the same twice over.

Interpreting Landscapes — Christopher Tilley

Now & Here | 2015 Asia/Next-Poster Experimental Design Exhibition | **DAEKI & JUN**

21 POSTER ANNUAL 2019 JUDGES DAEKI SHIM, HYOJUN SHIM

WHERE 01: MULTILINGUAL | International Poster Invitation Exhibition / Beijing Design Week 2015 | **DAEKI & JUN**

Graphis Platinum Awards

Opposite page: "The East Cut Launch Poster Series," designed by COLLINS

24 PLATINUM WINNERS

Rikke Hansen | Rikke Hansen | Designer | www.wheelsandwaves.dk | Page: **26**
Biography: Born in Denmark in 1975. Graphic Designer and Educator. Owner of a letterpress studio. Works and teaches in a field in the intersection between language, culture, and space. She has a passion for graphic design and typography and for working with design methods that provide students with ways to fundamentally understand society and its stakeholders' needs and how to drive these processes to useful results. For several years she has been working with product development, branding, and consulting for companies and organisations. She has been exhibiting and giving lectures and workshops internationally in Europe, Middle East, Asia and America.

Matthias Hofmann | hofmann.to | Designer | www.matthiashofmann.ch | Page: **27**
Biography: Matthias Hofmann is a self-employed graphic designer, born in 1970 in Basel, Switzerland. He founded different design studios and is owner of hofmann.to since 2010. His works are primarily poster and book designs for various clients in the cultural area. Matthias Hofmann is an instructor and critic for graphic design and typography at several design schools and his posters are exhibited and awarded in poster shows worldwide.

Fa-Hsiang Hu | hufax arts Co., Ltd./ CUTe | Executive Creative Director | Page: **28**
Biography: Fa-Hsiang Hu is a designer, creative director, and educator. MFA, National Taiwan Normal University. He is an assistant professor of Department of Visual and Communication Design at China University of Technology and also is an Executive Creative Director of hufax arts Co., Ltd. Director of Taiwan Graphic Design Association / Director of Taiwan Posters Design Association. ■ Hu's works has been recognized by the Taiwan Visual Design Award and numerous awards from leading design organizations and publications worldwide, including D&AD Awards, London International Awards, Red Dot Communication Design Award, Communication Arts, Golden Pins Awards, Hong Kong Designers Association, IDA, Graphis, and others. As well as his posters were won and selected into the international poster biennales in Warsaw, Bolivia, Macau, and others.

Gunter Rambow | Designer | www.gunter-rambow.de | Page: **30**
Biography: Gunter Rambow was born in 1938. When he was a child of 5 or 7 years—during the end of the Second World War—he lived a life of total awareness. This time had a formative influence on his complete graphic and photographic work. In 1954-58 he studied glass painting at Staatliche Glasfachschule Hadamar and in 1958-64 he studied graphics at HBK Kassel. Hans Hillmann was his professor who taught him his sense of form. In several of his own studio cooperations, Rambow created numerous photo books and designed poster series for literature, theatre, and social topics. This work continues up to now together with his wife Angelika. The "Bibliothèque Nationale" Paris, the "Akademie der Künste" Berlin, the "Deutsche Plakatmuseum" Essen, "Art Museum Shanghai" and many other institutions dedicated large single exhibitions to his work. He has won many silver and gold medals at poster festivals, biennials, and triennals in Warsawa, Chaumont, Lahti, Brno, Toyama, and more, and is a Platinum award winner of Graphis. He has been a member of the Alliance Graphique Internationale (AGI) since 1974. Between 1974 and 2004 he taught as a professor for visual communication at the University of Kassel and the "Staatliche Hochschule für Gestaltung Karlsruhe." Since 2004 he works and lives in Güstrow running a gallery for art in public space, and since 2011 his studio in Güstrow is a private research institute attached to HBKsaar, where he is Honorary Professor.

It was a joy to review such a vast range of work from so many different industries; the amount of compelling work is almost overwhelming. I hope that my contribution to this year's competition will inspire those to keep pushing the needle a little further.
Zach Minnich, *Communication Artist, Thirst*

The discipline of poster design is constantly evolving and is, to me, still the pinnacle of graphic design: it is often more related to art than to advertising and always pushes boundaries.
Fons Hickmann, *Founder, Fons Hickmann m23*

25 PLATINUM WINNERS

COLLINS | www.wearecollins.com | Page: **31**
Biography: COLLINS is an independent brand experience design company with offices in Manhattan and San Francisco that designs products, experiences, and communications which transform brands, drive business, and improve people's lives.
Poster Artists: Apexer, Caroline Bagley, Jacob Bang, Ryan Bosse, Fnnch, Mary Finlayson, LA Hall, Andreas Helin, Aleya Hoerlein, Essen International, Math Times Joy, Ben Klein, Julia Lemke, Daniel Lindqvist, Terri Loewenthal, Matt Luckhurst, Casey Martin, Gabrielle Matte, Mitch Mauk, Moniker, David Minh Nguyen, Rasmus Nilsson, Neil Nisbet, Michael Osborne, Erik Otto, Mike Payne, Steve Reinmuth, Victor Reyes, David John Scott, Karin Soukup, Michael Stark, Michael Taylor, Evan Tolleson, Erik Berger Vaage, Carl Valin, Christian Widlic

Peter Bell | **Traction Factory** | Executive Creative Director | www.tractionfactory.com | Page: **32**
Biography: During the course of his career, 27 years and counting, Peter has strived to bring ideas that are both strategic and creative to all brands that he has touched. The goal of being a brand steward to their target audiences and a partner to the brands with whom he has worked side by side shows deeply in the results of his creative endeavors. ■ Peter has brought great energy to both national and international brands alike, achieving new heights and incredible success for such clients as: Harley-Davidson Motor Company, The History Channel, Polaris Snowmobiles, JanSport Daypacks, TaylorMade Golf, Trek Bicycles, Famous Footwear, Snap-on Tools, ALS Association Wisconsin Chapter, and the Madison Museum of Contemporary Art, to name a few. ■ Throughout his years, Peter has been privileged to earn both national and international recognition for his work in advertising and design from such fine institutions as Communication Arts, Graphis, The One Show, Print Regional Design, HOW Design International Awards, Step Design 100 Showcase, MKE 99s, and even Dirt Rider magazine (for Product of the Year). ■ "It has been my good fortune to have worked with a caliber of folks that have been both talented and unrelenting in their quest to do the very best work possible. I have learned much from all of my colleagues and work hard to carry forward their legacies to the next group of talented young women and men in the hopes that I will have left this world a bit better than I have found it."

Patricia McElroy, Dermot MacCormack | **21XDesign** | Co-founders, Designers | www.21xdesign.com | Page: **33**
Biography: Patricia McElroy and Dermot MacCormack co-founded 21xdesign in 1997. The studio has since built a reputation for developing creative branding in print and interactive experiences. Their work has been honored with national and international design awards and exhibited in various countries. Between them, they bring a diverse set of experiences to their studio. Originally from Ireland, Dermot has worked in a number of design studios and agencies, working mostly in the corporate world before becoming involved in designing for the screen. He is also the Chair of the Graphic Arts & Design department at Tyler School of Art in Philadelphia. While Patricia was born in Philadelphia, The United States, she spent her formative years in Dublin, the Republic of Ireland, where they met while they both studied at the National College of Art & Design. Patricia brings her extensive publishing and design experience to combine with Dermot's focus on design for the screen. They have been designing posters for several years, and focus on themes that tackle critical social and political issues.

Bond/P+A/Ignition/Iconisus, FX Networks | www.fxnetworks.com | Page: **34**
Biography: The FX Networks Print Design Department, part of FX Marketing, creates original and unparalleled print advertising for all of FX Networks' original programming. The team aims to push the boundaries of entertainment advertising and commercial art in general. In years past, FX Print Design has created award-winning campaigns for shows like Nip/Tuck, American Horror Story, Sons of Anarchy, Atlanta, Taboo, and Fargo, among numerous others. The FX Marketing team is the winner of the Clio Key Art Awards' "Network of the Year" three years running and Promax/BDA "Marketing Team of the Year" all seven years the award has been presented.

Bond, FX Networks | Page: **35**
Biography: See above.

The pieces of work which resonated with me were simple, ideas-driven design solutions. I appreciated the bold and dynamic graphic impact of the successful work, particularly in the context of the medium being a poster. The uniquely crafted typographic and illustrative solutions were a joy to view.

Andrew Hoyne, *Principal, Hoyne*

26 RIKKE HANSEN PLATINUM

COMMEMORATIVE

Homage to Umberto Eco | BICeBé and National Museum of Art, La Paz | Rikke Hansen

27 MATTHIAS HOFMANN **PLATINUM** MUSIC 🇨🇭

The WOW Trio | Neustahl GmbH | hofmann.to

28 FA-HSIANG HU PLATINUM EDUCATION

2017.
11.
16
/
12.
14

一律採通訊報名（以郵戳為憑）

中國科技大學
視覺傳達設計系107學年度碩士班甄試招生

China University of Technology
Graduate Institute of Visual Communication and Design

〈視覺傳達設計領域、數位媒體設計領域、文化創意設計領域、插畫繪本設計領域、數位音樂設計領域〉

www.cute.edu.tw

Design is Future | China University of Technology | hufax arts Co., Ltd. / C.U.T.e

Tama Art University Doctoral Program Graduation Exhibition | Tama Art University | Takashi Akiyama Studio

Der Mieter (The Tenant) | Oper Frankfurt | Gunter Rambow

31 RASMUS NILSSON PLATINUM PROMOTION

The East Cut Launch Poster Series | The East Cut Community Board District | COLLINS

33 PATRICIA MCELROY, DERMOT MACCORMACK, JULIE LAM PLATINUM SOCIAL & POLITICAL

#NEVERAGAIN

#neveragain | Self-initiated | 21xdesign

PARKLAND - 02.14.18

34 P+A, TODD HEUGHENS, MICHAEL BRITTAIN, ROB WILSON (FX NETWORKS) **PLATINUM** — TELEVISION

AHS: Cult | FX Networks | Bond/P+A/Ignition/Iconisus

35 TODD HEUGHENS, STEPHANIE GIBBONS, MICHAEL BRITTAIN, ROB WILSON **PLATINUM** TELEVISION

AHS: Cult - BEE EYES | FX Networks | Iconisus

Graphis Gold Awards

Opposite page: "555 Collins," designed by Hoyne

38 ALLEN OKE, ANDREW CAIE, NOEL FENN, LISA PHUONG GOLD · AUTOMOTIVE

This Halloween, treat yourself to genuine Harley-Davidson® parts.

Halloween | Harley-Davidson Canada, Jay Own, Vesa Mikkola | Zulu Alpha Kilo

39 HYUK-JUNE JANG GOLD

AUTOMOTIVE

THE BMW,
coexists with nature
www.bmw.ca

The BMW Coexists with Nature | BMW | HYUK-JUNE JANG

BAYNA

RUČNO RAĐENA KREMA ZA RUKE IZ APOTEKE IVANČIĆ I SIN

KREMA ZA RUKE
sa biljnim uljima i vitaminima.
Hand made bez parabena.
MANGO

BAYNA body care | Ivancic i sinovi | SVIDesign

41 HUSMEE GOLD | COMMEMORATIVE

H+H
Husmee +
Helvetica

60th
Anniversary
Helvetica
Typeface

1957 / 2017
Tribute
Project

60helvetica.com

H+H
Husmee +
Helvetica

60th
Anniversary
Helvetica
Typeface

1957 / 2017
Tribute
Project

60helvetica.com

husmee.com

H + H / Husmee + Helvetica | 60th Anniversary Helvetica Typeface | Husmee

Homage to Umberto Eco | Bienal del Cartel Bolivia BICeBé | **Gravdahl Design**

43 FIDEL PEÑA, CLAIRE DAWSON GOLD

COMMEMORATIVE 🍁

In 1932, the Salvadoran military and civilian militias executed an estimated 10,000 to 30,000 people, the majority of whom were indigenous. The massacre was a swift and ruthless response to a rebellion led by rural labourers protesting violations of land rights, gross economic disparity and precarious living conditions.

The 1932 Massacre
"La Matanza"
—
El Salvador
January 22, 1932

Everyone, El Salvador | Self-initiated | Underline Studio

44 FIDEL PEÑA, CLAIRE DAWSON GOLD COMMEMORATIVE 🍁

The Massacre
at El Sumpul
—
El Salvador
May 14, 1980

14.
SUMPUL
05.
80

Within a couple hours more than 600 civilians were entrapped and shot or drowned in the Sumpul River, on May 14, 1980. The attack was led by the Salvadoran Army who closed in on unarmed civilians from the south. From the north side of the river, the Honduran Army prevented those fleeing the violence from entering Honduras. Those murdered were non-combatants, including women, children and the elderly, most of whom had been displaced due to fighting and were seeking refuge.

Everyone, El Salvador | Self-initiated | Underline Studio

45 KARI PIIPPO GOLD COMMEMORATIVE

Homage to Umberto Eco 1932-2016 | The Biennial of Poster Bolivia BICeBé | Kari Piippo Oy

47 RYAN MEIS *GOLD* — CORPORATE

Facebook Data Center Safety Posters | Facebook | Stout SF

48 KIYOUNG AN GOLD EDUCATION

「Design Day」of Graphic Art seminar in KINDAI | KINDAI university (Department of Arts) | Graphic Art seminar laboratory

49 JEREMY HONEA GOLD EDUCATION

DSVC DREAM DRIVE CINCO DE MAYO 2017

DSVC Golf Tournament Poster | Dallas Society of Visual Communications | **Jeremy Honea**

15. Message Illustration Poster 2017 | Tama Art University Illustration studies | Takashi Akiyama Studio

KINDAI university, kiyoung AN Visual design seminar PR poster | KINDAI university | Graphic Art seminar laboratory

52 ARSONAL GOLD

ENTERTAINMENT

Fargo S3 | FX Networks | ARSONAL

53 INSYNC PLUS, FX NETWORKS: STEPHANIE GIBBONS, TODD HEUGHENS, TODD RUSSELL GOLD ENTERTAINMENT

The Assassination of Gianni Versace: An American Crime Story | FX Networks | InSync PLUS

54 JEFF WADLEY, KISHAN MUTHUCUMARU **GOLD** ENTERTAINMENT

JENNIFER LAWRENCE JOEL EDGERTON MATTHIAS SCHOENAERTS and JEREMY IRONS

RED SPARROW

MARCH 2

#RedSparrow
RedSparrowMovie.com

Red Sparrow | 20th Century Fox | InSync PLUS

55 KISHAN MUTHUCUMARU, GREG SOTO GOLD

ENTERTAINMENT

Star Wars: The Last Jedi | Walt Disney Studios Motion Pictures | **InSync PLUS**

56 COLD OPEN GOLD — ENTERTAINMENT

Hunter Street - Season 2 | Nickelodeon | Cold Open

The Handmaid's Tale S1 | HULU | ARSONAL

Edén | Segunda Llamada | Scott Laserow Posters

59 PEP CARRIÓ GOLD ENVIRONMENT

LIGHT CITY

La ciudad ligera | DIMAD/Ayuntamiento de Madrid | **Estudio Pep Carrió**

60 **MICHAEL BRALEY** GOLD | EVENTS

ogaki
matsuri
festival

大垣まつり

Ogaki Matsuri Festival | Ogaki Matsuri Festival Competition | **Braley Design**

Lucy's Fried Chicken 7th Annual Revival | Lucy's Fried Chicken | Pentagram

AND·THEN·BLACK·NIGHT
THAT·BLACKNESS·WAS·SUBLIME
I·FELT·DISTRIBUTED·THROUGH
SPACE·AND·TIME○ONE·FOOT
UPON·A·MOUNTAINTOP·ONE
HAND○UNDER·THE·PEBBLES·OF
A·PANTING·STRAND○ONE·EAR
IN·ITALY·ONE·EYE·IN·SPAIN○IN
CAVES·MY·BLOOD·AND·THE
STARS·MY·BRAIN○THERE·WERE
DULL·THROBS·IN·MY·TRIASSIC
GREEN○OPTICAL·SPOTS·IN
UPPER·PLEISTOCENE○AN·ICY
SHIVER·DOWN·MY·AGE·OF
STONE○AND·ALL·TOMORROWS
IN·MY·FUNNY·BONE

—JOHN SHADE—
Pale Fire by Vladimir Nabokov

Eclipse Poster: Pale Fire | Self-initiated | **TOKY Branding + Design**

63 TAKASHI AKIYAMA GOLD EVENTS

Great Mangart | Mangart Committee | Takashi Akiyama Studio

ACTING BODIES: FROM BODY TO TEXT
FIELDWORK: OBSERVATION & RECORD
WORKSHOP 01: 17.10.14
12PM-15PM

현대카드
DESIGN LIBRARY

Fieldwork: Observation & Record | Hyundai Card Design Library / Korea Craft & Design Foundation(KCDF) / Typojanchi | DAEKI & JUN studio

65 DEAN POOLE, TYRONE OHIA GOLD EVENTS

APR 26—27 Mysterious beasts are summoned to Sandringham

NIGHT SAFARI

Auckland Council
Te Kaunihera o Tāmaki Makaurau

SATELLITES.CO.NZ

Satellites Season 2017 | Auckland Council | Alt Group

67 MARÍA PRADERA, LORENA SAYAVERA GOLD EVENTS

INTER/ACCIONES

Feria Cevisama

Inter/acciones

Feria Valencia

Muestra de Arquitectura e Interiorismo en Cerámica

Trans/hitos 2017

del 20 al 24 de febrero

Interacciones | ITC - Technology Center | Yinsen

FORKA PROJECT | Self-initiated | Center for Design Research

69 FONS HICKMANN GOLD EVENTS

Solotage – Festival für Ein-Mann-Frau-Orchester Neubad Luzern 30.3.–1.4. 2017

Solotage | Neubad Luzern | Fons Hickmann m23

70 LANNY SOMMESE GOLD EVENTS

CENTRAL PENNSYLVANIA FESTIVAL OF THE ARTS
DOWNTOWN STATE COLLEGE & THE PENN STATE CAMPUS JULY 8-10

Arts Festival | Pennsylvania Festival of the Arts | Sommese Design

71 GUNTER RAMBOW GOLD

EVENTS

Wurzeln, Kronen, Herbst (Roots, Crowns, Autumn) | HfG Karlsruhe | Gunter Rambow

1917-2017 | Golden Bee Moscow | **Gunter Rambow**

73 HAJIME TSUSHIMA GOLD EXHIBITS

The Wind | Korea National University of Arts | **Tsushima Design**

RESONANCE

75 WOODY PIRTLE, LUCAS PIRTLE **GOLD**

EXHIBITS

UBUNTU | Armando Milani | **Pirtle Design**

Takashi Akiyama Poster Nakanokuchi | Nakanokuchi memorial hall one's predecessor | **Takashi Akiyama Studio**

77 JOÃO MACHADO GOLD EXHIBITS

JOÃO MACHADO
ARTE DA COR

MACNA Museu de Arte Contemporânea Nadir Afonso CHAVES

28 OUT.017
8 ABR.018

João Machado Arte da Cor | MACNA - Museu de Arte Contemporânea Nadir Afonso | João Machado Design

78 MELCHIOR IMBODEN GOLD

EXHIBITS

Borders | **Invited AGI Poster Exhibition** | **Melchior Imboden**

Resonance Angel | Asia Network Beyond Design | Randy Clark

Imagery of Social Media | The language of war and peace in the new media | **Hoon-Dong Chung**

81 SHAWN MEEK, SIXTO JUAN-ZAVALA **GOLD** EXHIBITS

Sixto Juan-Zavala: Visiting Artist, Scholar and Designer | Metropolitan State University of Denver | Shawn Meek & Sixto Juan-Zavala

83 SEAN CARTER GOLD — FESTIVALS

THE VANCOUVER WRITERS FEST

REIMAGINE YOUR WORLD

OCT 16–22 2017

110+ AUTHORS / 95+ EVENTS

DISCOVER THE LINEUP AT WRITERSFEST.BC.CA

Granville Island

2017 Vancouver Writers Fest | Vancouver Writers Fest | Carter Hales Design Lab Inc.

84 SEAN CARTER GOLD — FESTIVALS

85 ONUR GOKALP, DOGUKAN KARAPINAR GOLD FESTIVALS 🇹🇷

BEYKOZ KUNDURA RESTORE FİLM GÜNLERİ

05-13 Ağustos 2017

Sinema Klasiklerini Yeniden Keşfet!

www.restore.film

Beykoz Kundura Restored Film Days | Beykoz Kundura | Monroe Creative Studio

86 ONUR GÖKALP, DOĞUKAN KARAPINAR GOLD — FESTIVALS

BEYKOZ KUNDURA
RESTORE FİLM GÜNLERİ

05-13 Ağustos 2017

Sinema Klasiklerini Yeniden Keşfet!

BEYKOZ KUNDURA

Biletler için Mobilet

www.restore.film

Beykoz Kundura Restored Film Days | Beykoz Kundura | Monroe Creative Studio

87 JOÃO MACHADO **GOLD** FESTIVALS

Cinanima | Nascente Cooperativa de Acção Cultural, CRL | **João Machado Design**

65 Festival de San Sebastián

Donostia Zinemaldia

International Film Festival

sansebastianfestival.com

22 - 30 Iraila Septiembre

2017

GAUDEAMUS MUZIEKWEEK

UTRECHT 6–10 SEPTEMBER 2017

presents young music pioneers
WWW.GAUDEAMUS.NL

90 TOM VENTRESS GOLD — FOOD & BEVERAGE

ASGARD

VOYAGER PALE WHEAT ALE

Bright & Bracing With Just A Touch Of Hops

BREWING COMPANY

COLUMBIA · TENNESSEE

Asgard Voyager Beer Poster | Asgard Brewing Company | **Ventress Design Works**

91 RAFAEL FERNANDES **GOLD** FOOD & BEVERAGE

nipponbebidas.com.br

Nippon
Japanese beverages

Bottle Cap Flag | **Nippon Beverages** | **Angry Dog**

92 MICHAEL BRALEY GOLD — LECTURES

MICHAEL
BRALEY
CREATIVE
DIRECTOR
BRALEY
DESIGN
AAF
CEDAR
RAPIDS
IOWA
CITY
CEDAR
GRAPHICS
THINK
TO INK
09.21.17

Creative Connections | AAF Cedar Rapids / Iowa City | **Braley Design**

Kunsthalle zu Kiel

Sammlungspräsentation Cao Fei
mit den Gästen Hiwa K
Mika Rottenberg

GLOBALOCAL

Schleswig-Holsteinischer Kunstverein
175 Jahre für die Kunst

24.02.2018 – 13.01.2019

95 JOÃO MACHADO GOLD

MUSEUM 🇵🇹

大垣まつり

OGAKI MATSURI FESTIVAL

©2017 Design/JOÃO MACHADO

Ogaki Matsuri Festival | Ogaki Poster Museum | João Machado

OH WOW | Weserburg Museum for modern Art, Bremen and University of the Arts, Bremen | **studio lindhorst-emme**

97 MELCHIOR IMBODEN GOLD MUSEUM 🇨🇭

100 years of the Russian Revolution 1917–2017 | Invitational poster exhibition | **Melchior Imboden**

98 FONS HICKMANN GOLD

MUSIC

The Cloche
10. November 17
21.00 Konzert
Neubad
Luzern

The Cloche | Neubad Luzern | Fons Hickmann m23

99 MICHAEL BRALEY GOLD | MUSIC

St. Paul & The Broken Bones

Lexington Opera House
Lexington, Kentucky

November 15, 2017
with The Gripsweats

November 16, 2017
with Skyway Man

St. Paul & The Broken Bones | St. Paul & The Broken Bones | **Braley Design**

Mac DeMarco | Another Planet Entertainment | THERE IS Studio

101 THERE IS STUDIO **GOLD** MUSIC 🇬🇧

ANOTHER PLANET ENTERTAINMENT
PRESENTS

VAN MORRISON

SHANA MORRISON FOX THEATER
OAKLAND, CALIFORNIA
OCTOBER 20ᵗʰ & 21ˢᵗ, 2017

©ANOTHERPLANETENTERTAINMENT 2017 _ NO. 377 _ DESIGN BY SEAN FREEMAN & EVE STEBEN

Van Morrison | Another Planet Entertainment | THERE IS Studio

Akademie Konzerte Nationaltheater-Orchester Mannheim

Tschaikowski
Violinkonzert D-Dur op. 35
Rachmaninow
Symphonie Nr. 2 e-Moll op. 27

06. & 07.
November 2017
20 Uhr
Rosengarten

Stefan Blunier
Dirigent
Olga Pogorelova
Violine

Infos und Karten: 0621 26044 www.musikalische-akademie.de

Jacob Philipp Hackert, *Die Eruption des Ätna*, 1763

Cosi Fan Tutte | Oper Frankfurt | Gunter Rambow

Billy Budd | Oper Frankfurt | Gunter Rambow

105 STEPHAN BUNDI GOLD — OPERA 🇨🇭

FRANZ LEHÁR
DIE LUSTIGE WITWE
LA VEUVE JOYEUSE

THEATER BIEL BIENNE AB / DES LE 15|12|2017
ORCHESTRE SOLOTHURN AB 25|01|2018

The Merry Widow (German: Die lustige Witwe) | Theater Orchester Biel Solothurn | Atelier Bundi AG

Peter Grimes | Oper Frankfurt | Gunter Rambow

107 ANTHONY P. RHODES, GAIL ANDERSON GOLD — PROMOTION

Chris Buzelli SVA Subway Posters | School of Visual Arts | Visual Arts Press, Ltd.

108 **ANTHONY P. RHODES, GAIL ANDERSON** GOLD | PROMOTION

Chris Buzelli SVA Subway Posters | School of Visual Arts | Visual Arts Press, Ltd.

Body & Typography: 3rd Pre-Seminar & Talk | Korea Craft & Design Foundation(KCDF), Typojanchi 2017 | **DAEKI & JUN studio**

JOÃOPACKAGEMACHADODESIGN

João Package Machado Design | Self-initiated | João Machado Design

| 111 | JORDAN KABALKA GOLD | | PROMOTION |

THE USS MOBILE (LCS 26)

USS Mobile | Austal USA | Red Square

112 **PEP CARRIÓ** GOLD PROMOTION

BIBLIOTECA PALERMO

Biblioteca Palermo "casa pájaro" | **Artes Gráficas Palermo** | **Estudio Pep Carrió**

ROOFTOP PRIDE PARTY!

BOTTOMS ARE ALSO WELCOME

NADJA CHATTI (STHLM)

PJOTR (RED CURLS | POLARI | BERLIN)

HORSE MEAT DISCO (STRUT | !K7 | LONDON)

HOSTESS: MISS TOBI

TAK
BRUNKEBERGSTORG 2-4

TUESDAY 1 AUG 18-00

Gaysha | TAK | Behind the Amusement Park

114 MICHAEL BRALEY GOLD PUBLIC & SOCIAL SERVICES

Juntos podemos construir La Ciudad Ligera

Let's all build The Light City

Juntos podemos construir La Ciudad Ligera

La Ciudad Ligera / The Light City | **Madrid Grafica** | **Braley Design**

The world without surveillance! | Byoung-il Sun | Namseoul University

116 **BUCK SMITH** GOLD │ **PUBLIC & SOCIAL SERVICES**

FLEISHMANHILLARD GOLF CHAMPIONSHIP
SUNDAY, JUNE 11 | NORMAN K. PROBSTEIN COURSE IN FOREST PARK | TEE TIME 7:30 AM

Golf Tournament | Self-initiated | FleishmanHillard

HAMLET
WILLIAM SHAKESPEARE

HAMLET | Haller Metalwerks | Carmit Design Studio

MANLY BEACH, SYDNEY
MADE PROPERTY

———

33.7932° S, 151.2876° E

PARADISE
FOUND

PURE BEACHFRONT
LIVING

SHORELINE

Shoreline | Made Property Group | Hoyne

119 NICK FELS **GOLD** REAL ESTATE

555 COLLINS

555 Collins | Fragrance Group | Hoyne

555
COLLINS

555
COLLINS

121 | JAMES FITZGERALD, PETE GEORGIOU **GOLD** — REAL ESTATE

RETURN TO LA DOLCE VITA

Epicure | Changfa | Hoyne

9○ MORTON

Even the simplest details like an entryway are fully considered.

Graphis archigraphia redux Richard Poulin
CONCRETE

Details

90 Morton Sales Gallery
90 Morton Street
New York, NY 10014
Opening April 11, 2018

Details | Brack Capital Real Estate | IF Studio

90 MORTON

What is matter? What matters? Sculptures purposely crafted for a non-purpose.

By Danielle Gottesman

90 Morton Sales Gallery
90 Morton Street
New York, NY 10014

Opening April 11, 2018

objects

Objects | Brack Capital Real Estate | IF Studio

124 RUBY AITKEN, NICK FELLS **GOLD** **REAL ESTATE**

LASCELLES
TOORAK

Lascelles | Techin | Hoyne

125 MYKOLA KOVALENKO GOLD SOCIAL & POLITICAL

100th anniversary of the Revolution in Russia | 1917-2017

1917-2017 | Golden Bee Moscow | dnkstudio

126 **BORIS LJUBICIC** GOLD

SOCIAL & POLITICAL

+ - = | Self-initiated | **STUDIO INTERNATIONAL**

127 JOHN GRAVDAHL GOLD SOCIAL & POLITICAL

RESIST

RESIST | Posters for Peace | Gravdahl Design

HOME SWEET HOME

THIRD AMENDMENT — NO SOLDIER SHALL, IN TIME OF PEACE BE QUARTERED IN ANY HOUSE, WITHOUT THE CONSENT OF THE OWNER, NOR IN TIME OF WAR, BUT IN A MANNER TO BE PRESCRIBED BY LAW.

Home Sweet Home | "We the People" project | **Pentagram**

129 MARLENA BUCZEK SMITH GOLD SOCIAL & POLITICAL

DELETING IN PROGRESS

Deleting in Progress | Self-initiated | Marlena Buczek Smith

130 **BEGUM GUCUK GOLD** — SOCIAL & POLITICAL

TERRORISM

terrorism | Self-initiated | begum gucuk

131 STEPHAN BUNDI GOLD SOCIAL & POLITICAL

1917–2017

1917–2017 (100 years russian revolution) | Golden Bee Moscow | Atelier Bundi AG

unite
unite
unite

IN SUPPORT OF AUSTRALIA'S FIRST PEOPLES & THEIR RIGHT TO A FAIR AND JUST SOCIETY.

The evolution of the candlelight protests in South Korea | Self-initiated | Jun Bum Shin

134 **TOMASO MARCOLLA** GOLD　　　　　　　　　　　　　　　　　　　　　　　　　　　　　　　SOCIAL & POLITICAL

135 **RIKKE HANSEN** GOLD SOCIAL & POLITICAL

DANGEROUS WORLD NOW

EMPTY

A BETTER WORLD TOMORROW

EMP(A)T(H)Y | Speak UP | Rikke Hansen

BLACK BENTO

HIROSHIMA APPEALS POSTERS BOOK 1983-2017

くろい おべんとう

1945年8月6日8時15分、広島。

HIROSHIMA at 8:15 a.m. in August 6 1945

At Hiroshima Peace Memorial Museum, there are the remains of a lunch box that was exposed to the atomic bomb. The owner of the lunch box was Shigeru, a first year junior high school student. On the morning of August 6, he left home early in the morning to work in removing buildings. The dishes in the lunch box had been made by his mother using the first harvest from their garden on land which Shigeru had reclaimed. He was delighted by the lunch box which his mother had made with love for him.*

The lunch box is also a symbol of love and peace. We were unable to take my eyes off of its pitiful, damaged form. The theme of love is all the more important at the site of an atomic bombing. How is it possible to express this? While pondering this question, I sought guidance from the lunch box, filled as it was with selfless love, as I produced the Hiroshima Appeals Posters 1983-2017. It is my hope that the Hiroshima Appeals project can move as many people as possible with what is not forgotten, what continues to be told, and what can be achieved.

*From Database of Hiroshima Peace Memorial Museum

Giver: Shigeko Orimen
Holder: Shigeru Orimen

BLACK BENTO | Japan Graphic Designers Association Hiroshima | Tsushima Design

138 **MICHAEL BRALEY** GOLD — SOCIAL & POLITICAL

Have a respect for your neighbor's feelings and thoughts. — D.S. Likhachev

Neighbors Respect | Third Open All-Russian Poster Competition | Braley Design

139 **MARLENA BUCZEK SMITH** GOLD — SOCIAL & POLITICAL

DISARMAMENT
~~NUCLEAR WEAPONS~~

Disarmament | Self-initiated | **Marlena Buczek Smith**

DESERTIFICATION OF A TREE

Mass Start | 2018 PyeongChang Olympic | Freelance

143 STEPHAN BUNDI GOLD THEATER

Biedermann und die Brandstifter (The Fire Raisers) | Theater Orchester Biel Solothurn | Atelier Bundi AG

İNSAN KULAĞI / THE HUMAN EAR

YAZAN
ALEXANDRA WOOD

YÖNETEN
MURAT DALTABAN

ÇEVİREN
MELİSA KESMEZ

2. YÖNETMEN
MERT ÖNER

OYUNCULAR
ESİN ALPOGAN
SERHAT TEOMAN

SAHNELENME HAKKI ALEXANDRA WOOD'UN TEMSİLCİSİ ONK AJANS'TAN ALINMIŞTIR.

DOTkanyonda:
LEVENT KANYON,
TERAS KAT
BÜYÜKDERE CD.
NO:185
ŞİŞLİ İSTANBUL
0212 232 48 28
0212 251 45 45
www.go-dot.org

DOTKANYONDA'NIN KURUMSAL DESTEKÇİLERİ: AYGAZ, MITSUBISHI ELECTRIC KLİMA SİSTEMLERİ, mavi, Tüpraş, Opet

dot

Human Ear | DOT Theatre | H.Tuncay Design

145 STEPHAN BUNDI GOLD — THEATER

Terror | Theater Orchester Biel Solothurn | Atelier Bundi AG

146 CHRISTOPHER LUECK, BRIANA LYNCH GOLD — THEATER

MANON
IN MANHATTAN

Manon in Manhattan Key Art Poster | GlobalMusicDrama LTD | The Pekoe Group

147 RAY REDDING, SPENCER STRICKLAND **GOLD**

THEATER

SONG ABOUT HIMSELF

BY MICKLE MAHER

the CATASTROPHIC theatre

Song About Himself | The Catastrophic Theatre | Langrand

148 STEPHAN BUNDI GOLD — THEATER 🇨🇭

A Christmas Carol | Theater Orchester Biel Solothurn | Atelier Bundi AG

149 RAY REDDING, SPENCER STRICKLAND **GOLD** THEATER

SNOW WHITE BY DONALD BARTHELME

the CATASTROPHIC theatre

DIRECTED BY GREG DEAN

Snow White | The Catastrophic Theatre | Langrand

150 CARMIT HALLER GOLD　　　　　　　　　　　　　　　　　　　　　　　THEATER

WILLIAM SHAKESPEARE
MACBETH

Macbeth | Haller Metalwerks | Carmit Design Studio

151 ERIC THOELKE, KELCEY TOWELL GOLD TYPOGRAPHY

ART
ARCHITECTURE
LITERATURE
DANCE
FASHION
MUSIC
DESIGN
POETRY
MIXOLOGY
PERFORMANCE
CUISINE

CREATIVE PROCESS monthly gathering that highlights St. Louis' image as a creative city through fostering cross-disciplinary collaborations.

September 27
6:00 – 8:00 pm

SAINT LOUIS FASHION INCUBATOR
at 1533 Washington Avenue

SAINT LOUIS FASHION FUND

Creative Process Poster | Creative Process/St. Louis Fashion Fund | **TOKY Branding + Design**

152 JORDAN CULLEN, RYAN BOSSE GOLD

TYPOGRAPHY

Stout Typographic Posters | Self-initiated | **Stout SF**

153 FA-HSIANG HU GOLD

TYPOGRAPHY

A Good Fortune As One Wishes!

Best Wishes | TPDA | hufax arts Co.,Ltd./ CUTe

Graphis Silver Awards

Opposite page: "Top Chef S15," designed by ARSONAL

156 SILVER

STEPHAN BUNDI 🇨🇭

Architektur aus Wien: überzeugend anders
Architektur Forum Bern | **Atelier Bundi AG**

EMIRHAN AKYUZ 🇹🇷

Geberit Arkitera Architecture Travel Scholarship
Geberit | **Monroe Creative Studio**

IRINA GORYACHEVA 🇱🇹

The New Moscow
Center of Russian Avant-garde | **Dizaino Studija Baklazanas**

SHERRI KREKELER, GLEN DAY 🇺🇸

Audi Heritage Poster Series
Audi of America | **TracyLocke**

157 **SILVER**

MARKHAM CRONIN

Das Renn Treffen Posters 2017 | Das Renn Treffen | Markham & Stein

ATSUSHI ISHIGURO, RISA UEDA

LUMINE LIFE IS JOURNEY | LUMINE CO.,LTD. | OUWN

BOB WARKULWIZ

AIGA Founders | AIGA Philly 35th Anniversary
Warkulwiz Design Associates Warkulwiz Design Associates

KARI PIIPPO

Che Guevara 1928-1967 | Universidad Autónoma Metropolitana
Kari Piippo Oy

158 SILVER

JOÃO MACHADO

50CHE | Universidad Autónoma Metropolitana Mexico
João Machado Design

BOB AUFULDISH

CCA Gala Honoring David Kelley | California College of the Arts
Aufuldish & Warinner

PEP CARRIÓ, SANDRA TENORIO

60th Anniversary Helvetica Typeface
Husmee Studio Graphique! | Estudio Pep Carrió

BRENDAN McMULLEN

No Spec Posters
Self-initiated | Zulu Alpha Kilo

159 SILVER

DAVID L. SIGMAN 🇺🇸

Spring Dance Works 2017
Purdue Contemporary Dance Company | Purdue University

BRIAN DELANEY 🇺🇸

STEM Classroom poster
VEX Robotics, Inc. | VEX Robotics in-house studio

KIYOUNG AN 🇯🇵

KINDAI university Graphic Art & Design course PR poster
KINDAI university | Graphic Art Seminar Laboratory.

TAKASHI AKIYAMA 🇯🇵

100 views of Tama Art University-4 / Dessin-7 100 view·Tree
Tama Art University Dessin Project | Takashi Akiyama studio

160 SILVER

COLD OPEN

Runaways - Character Series | Hulu | Cold Open

PETROL ADVERTISING

Destiny 2 | Activision | Petrol Advertising

PETROL ADVERTISING

Destiny 2 | Activision | Petrol Advertising

161 SILVER

COLD OPEN

Mind Field - Season 2 | YouTube Red | Cold Open

ARSONAL / FX NETWORKS

Atlanta S2 | FX Networks | ARSONAL

ARSONAL

Top Chef S15 | Bravo | ARSONAL

ARSONAL, FX NETWORKS

The Strain S4 | FX Networks | ARSONAL

162 SILVER

TED WRIGHT

Pendelton Rodeo Days, The Legendary Johnny Cash, A Great Big Texas Howdy
Pendelton, The Johnny Cash Museum/Nashville, Brian Houser | Ted Wright Illustration & Design

HBO LATIN AMERICA

EL HIPNOTIZADOR | Self-initiated | HBO Latin America

ARSONAL

Thoroughbreds - Key Art | Focus Features | ARSONAL

163 SILVER

ARSONAL	PETROL ADVERTISING				
Darkest Hour - Key Art	Focus Features	ARSONAL	Call of Duty: WW2	Activision	Petrol Advertising
COLD OPEN	ARSONAL				
Lindsey Stirling: Brave Enough	YouTube Red	Cold Open	Darkest Hour - Teaser	Focus Features	ARSONAL

164 SILVER

RIKKE HANSEN

Out of Sight out of Mind – E-waste is not somebody else's problem
BICeBé | Rikke Hansen

DAN ELLIS, SCOTT LAMBERT

Leaving Impressions
Singapore Parks | Superunion

DAISUKE KASHIWA

Homage to Umberto Eco
The Biennial of the Poster Bolivia BICeBé | Daisuke Kashiwa

MICHAEL BRALEY

Roadtrip to Pando
Pando Populus | Braley Design

165 SILVER

YIN ZHONGJUN

Honker | Poland Auschwitz international political Poster Biennale
Dalian RYCX Advertising Co., Ltd.

MICHAEL BRALEY

Water and Power Blitz | Pando Populus
Braley Design

NAOYUKI FUKUMOTO

22nd JFACE Annual Conference
Japanese Academy of Facial Studies | imageon CO., LTD.

MICHAEL SCHWAB

Shasta Camera Fund
Shasta Ventures | Michael Schwab Studio

166 SILVER

MICHAEL BRALEY

Campando Maryknoll | Pando Populus | Braley Design

MICHAEL BRALEY

The Futures of Death Alley | Pando Populus | Braley Design

LANNY SOMMESE

Arts Festival | Pennsylvania Festival of the Arts | Sommese Design

KELLY HOLOHAN, PAUL KEPPLE

LGBTQ Mixer | AIGA Philadelphia | Penrose 300

167 SILVER

TED WRIGHT

Pendelton Way Out West | Pendelton | Ted Wright Illustration & Design

VITALY STAVITSKY

7th Assembly of RDA
Russia Designers Association (RDA) | Stavitsky Design

CHIKAKO OGUMA

Irodori Tea Party
Nihonbashi Mitsukoshi | Chikako Oguma

168 SILVER

R.P. BISSLAND

The Gardener's Market Poster 2017
Cache Valley Gardener's Market Association | **Design SubTerra**

GONCA KOYUNCU

JEFF TALKS: MELİKE TAŞCIOĞLU
Manifold | **Gonca Koyuncu**

WINNIE WU

SO-CA Salon Vol. 1 | School of Clay Arts | **studioKALEIDO**

SELMAN DESIGN

The Great Dumbo Drop | The Dumbo Improvement District | **Selman Design**

169 SILVER

DJ STOUT, HALEY TAYLOR

Pecha Kucha 29
Pecha Kucha Austin | **Pentagram**

JUREK WAJDOWICZ, JUREK WAJDOWICZ, MANNY MENDEZ

Global Citizen NYC Concert Poster
Global Citizen | **Emerson, Wajdowicz Studios**

ERIC THOELKE, JUSTIN STRIEBEL

Eclipse Myths | Client | **TOKY Branding + Design**

170 SILVER

SVEN LINDHORTS-EMME

V | R. - Raum für drastische Maßnahmen
studio lindhorst-emme

DAVID TORRENTS

This is a public wall! (Això és una paret pública!) | Marc Martí
David Torrents

MI-JUNG LEE

Beautiful Dokdo | Ministry of Culture, Sports and Tourism | Woosuk Uni.

NORIKYUKI KASAI

BODY | JAGDA Hokkaido | Norikyuki Kasai

171 SILVER

FONS HICKMANN 🇩🇪

Franz Kafka Metamorphosis | Posterbiennal Mexico | **Fons Hickmann m23**

SCOTT SUGIUCHI, EMILEE BEESON, RACHEL VENTURA 🇺🇸

CSX FFA Posters | CSX Transportation, John Kitchens, CSX | **Exit10**

DAISUKE KASHIWA

Postgraduate Illustration Studies, Graduate Exhibition 2017
Illustration Studies, Tama Art University | **Daisuke Kashiwa**

LINDA RITOH

LIFE—Linda Ritoh, The exhibition with photographers, 2017, Osaka
Heiwa Paper Co., Ltd / Paper Voice | **Libido inc.& Linda Graphica**

172 SILVER

RANDY CLARK

Resonancia | Asia Network Beyond Design | Randy Clark

MEHMET ALI TÜRKMEN

Beruf (Occupation) | Westend Fotoschule, Bremen | MAT

LEO LIN

Poster exhibition for the soliloquy of word
Taiwan Poster Design Association | Leo Lin Design

LINDA RITOH

LIFE—Linda Ritoh, The exhibition with photographers, 2017, Osaka
Heiwa Paper Co., Ltd / Paper Voice | Libido inc.& Linda Graphica

173 SILVER

DILARA SEBNEM ESENDEMIR

36th GMK Graphic Design Exhibition
GMK Graphic Designers AssociationTurkey | **Dilara Sebnem Esendemir**

JIE-FEI YANG

Mother
Strelka Design Biennale competition | **Jie-Fei Yang**

FINN NYGAARD

Posters Without Borders exhibition
Art at the University of Alabama at Birmingham | **Finn Nygaard**

JOÃO MACHADO

Novas Glórias
Clube Criativos de Portugal | **João Machado Design**

174 SILVER

DOĞAN ARSLAN

Jazz in the ruins | Jazz W Ruinach
Doğan Arslan

JOÃO MACHADO

Cinanima | Nascente Cooperativa de Acção Cultural, CRL
João Machado Design

STEVE SANDSTROM, MOLLY KENNEDY-DARLING

41st Portland International Film Festival
Northwest Film Center | **Sandstrom Partners**

HEATHER ATHEY, MELANIE PRISCO

SCAD AnimationFest
Self-initiated | **Savannah College of Art and Design**

175 SILVER

HEATHER ATHEY, JENNIFER MCCARN 🇺🇸

SCAD GamingFest
Self-initiated | Savannah College of Art and Design

SHERRY JANG, CHELSEA PALMER 🇨🇦

Bard on the Beach Rebranding
Bard on the Beach | Carter Hales Design Lab Inc.

PETER BANKOV 🇨🇿

Moscow film festival
MIEF company | BANKOVPOSTERS

PEP CARRIÓ 🇪🇸

Premio de Novela Gráfica Ciudades Iberoamericanas
UCCI Unión de Ciudades Capitales Iberoamericanas | Estudio Pep Carrió

176 SILVER

JORGE POMAREDA

Wall | Chicago Latino Film Festival
LaMachina Design Co.

WILL HACKLEY

RiverRun International Film Festival Rare Finds
RiverRun International Film Festival | **Elephant In The Room**

CHARIT PUSIRI

The Pink Glasses Murderer | Ardel | **Charit Art Co.,Ltd.**

177 SILVER

HENNING KREITEL

Lecture announcement: Luther and the Places of Reformation
Zentral- und Landesbibliothek Berlin | **Henning Kreitel**

JOÃO MACHADO

Terras Gauda
Terras Gauda Francisco Mantecón | **João Machado Design**

TED WRIGHT, DAWN JANNEY

Jingle All The Way - Williams Sonoma | Williams Sonoma - California | **Ted Wright Illustration & Design**

178 SILVER

KAVEH HAERIAN

WTMD Radio First Thursday Concert | WTMD Radio | Kaveh Haerian

SASHA VIDAKOVIC

YES Naked - CD album | Naked | SVIDesign

MARTIN FRENCH

Monk 100
Self-initiated | Martin French Studio

MOLLY TUTTLE

Shaddox / Mulligan Poster
Billy Shaddox & Dave Mulligan | Molly Tuttle Design

179 SILVER

ONUR GOKALP, EMIRHAN AKYUZ, EMRE KIZILDELIOGLU

Minimalismus+
Kabak&Lin | **Monroe Creative Studio**

OWEN GILDERSLEEVE

Outside Lands Poster
Another Planet Entertainment & Superfly | **Owen Gildersleeve Ltd.**

LARRY SMITH, R.P. BISSLAND

Jazz Kicks Band play Strayhorn
Jazz Kicks Band | **Design SubTerra**

CARLO FIORE

Der fliegende Holländer
Accademia Nazionale di Santa Cecilia | **Venti caratteruzzi**

180 SILVER

GUNTER RAMBOW

Il Trovatore | Oper Frankfurt | Gunter Rambow

GUNTER RAMBOW

Das Rheingold | Oper Frankfurt | Gunter Rambow

GUNTER RAMBOW

Norma | Oper Frankfurt | Gunter Rambow

GUNTER RAMBOW

Die Lustige Witwe (The Merry Widow) | Oper Frankfurt | Gunter Rambow

181 SILVER

GUNTER RAMBOW 🇩🇪

L'Africaine, Vasco Da Gama | Oper Frankfurt | **Gunter Rambow**

GUNTER RAMBOW 🇩🇪

Capriccio | Oper Frankfurt | **Gunter Rambow**

SIMON ELLIOTT, ROSE, TOBY EDWARDS, ALI BOSCHEN 🇬🇧

ENO Aida
English National Opera | **Rose**

TETSURO MINORIKAWA 🇯🇵

Ogaki Matsuri Festival
Ogaki Matsuri Festival Poster Exhibition Committee | **Tetsuro Minorikawa**

182 SILVER

CARMIT HALLER

TOSCA | Haller Metalwerks | Carmit Design Studio

EINAR GYLFASON

Wi-Fi Free Zone
Flothetta | Leynivopnid

JOHAN RESSLE, HELENE HAVRO

Behind the Amusement Park Launch Party
Self-initiated | Behind the Amusement Park

183 SILVER

MCCANDLISS AND CAMPBELL

Dream Big
Self-initiated | McCandliss and Campbell

ANTHONY P. RHODES, GAIL ANDERSON, MILTON GLASER

Milton Glaser SVA Subway Posters
School of Visual Arts | Visual Arts Press, Ltd.

MI-JUNG LEE

You can do it at woosuk! | Self-initiated | Woosuk University

BOB AUFULDISH

Homing In: Todd Hido B-Sides | Editions Editions | Aufuldish & Warinner

184 SILVER

BOB AUFULDISH

Miyajima Hatsumoude 2018
Miyajima Tourist Association | **Aufuldish & Warinner**

ANDREW ROSS, DEBORAH OSBORNE

This is Vivid
Boss Print | **Osborne Ross**

YAOYAO HUANG

Poster series | **Jin San Yi Silk Store** | **Oncetudio**

MATT LUCKHURST, SOHEE KIM

TI Yomar Augusto Visiting Designer Poster | Self-initiated | **COLLINS**

185 SILVER

ANTHONY P. RHODES, GAIL ANDERSON, RYAN DURINICK

Edel Rodriguez SVA Subway Posters
School of Visual Arts | **Visual Arts Press, Ltd.**

MATT PETERS, CLAUDIA MARK

Agency Mission Internal Communications
Self-initiated | **DiMassimo Goldstein**

THOMAS HUTCHINGS

Wanda Promotion Poster
Self-initiated | **Landor San Francisco**

DAEKI SHIM, HYOJUN SHIM

Typojanchi 2017 - Body & Typography 01
Korea Crafts & Design Foundation | **Daeki Shim, Hyojun Shim**

186 SILVER

DAEKI SHIM, HYOJUN SHIM

Typojanchi 2017 - Body & Typography 01
Korea Crafts & Design Foundation | **Daeki Shim, Hyojun Shim**

HUANG YONG

Save the whales
cow design biennale | **NICE CREATIVE**

MIKE MAZZA

That Crazy Perfect Someday Book Poster
Turtle Point Press | **Mazzarium Inc.**

GERAY GENCER

Faces
Faculty of Fine Arts - Marmara University | **Studio Geray Gencer**

187 **SILVER**

LINDY MARTIN

Faceout Studio Poster | Self-initiated | Faceout Studio

NICK FELS

Waverley Park | Mirvac | Hoyne

HISA IDE, TOSHIAKI IDE, KUMIKO IDE

Essence | Brack Capital Real Estate | IF Studio

HISA IDE, TOSHIAKI IDE, KUMIKO IDE

Textures | Brack Capital Real Estate | IF Studio

188 SILVER

HISA IDE, TOSHIAKI IDE, KUMIKO IDE

Retreat | Brack Capital Real Estate | **IF Studio**

PETER GEORGIOU, PETER DREW

Workshop | Milligan Group | **Hoyne**

B. TABOLT, K. PAWLOWSKI, B. HERNALSTEEN, B. HALDEMAN

330 N Wabash Poster Series
Beacon Capital Partners, Cushman & Wakefield | **Pivot Design**

HISA IDE, TOSHIAKI IDE

East Village's Greatest Building
Extell Development | **IF Studio**

189 SILVER

KARI PIIPPO

Utopia | Goethe-Institut Israel | Kari Piippo Oy

TOYOTSUGU ITOH

GROUND ZERO | Chubu Creators Club | Toyotsugu Itoh Design Office

HOON-DONG CHUNG

Tolerance | Tolerance - a traveling poster project | Dankook University

JUSTIN KEMERLING

Climate of Denial | America | Justin Kemerling Design Co

190 SILVER

ANDREW SLOAN 🇬🇧

Another War
Self-initiated | Andrew Sloan

YOHEI TAKAHASHI 🇯🇵

Earthquake Poster Support Project
Tama Art University, Tokyo polytechnic University | Yohei Takahashi

FONS HICKMANN 🇩🇪

War is Stupid
Self-initiated
Fons Hickmann m23

RYAN RUSSELL 🇺🇸

Deconstructing Hate
H. Campbell & Eleanor R. Stuckeman School of Architecture & Landscape Architecture, The Pennsylvania State University | Ryan Russell Design

191 SILVER

YIN ZHONGJUN

Nanjing Massacre 1937 | Nanjing Graphic Designers Union Nanjing Museum | Dalian RYCX Advertising Co., Ltd.

RENE V. STEINER

Patience | Self-initiated | Steiner Graphics

MICHAEL BRALEY

Tolerance | Anfachen Award | Braley Design

192 SILVER

MICHAEL BRALEY

Togetherness | Third Open All-Russian Poster Competition | Braley Design

HISA IDE, TOSHIAKI IDE, MAGNUS GJOEN

War or Peace | Self-initiated | IF Studio & Magnus Gjoen

MYKOLA KOVALENKO

Falling Skies | 4th block | dnkstudio

T. HEUGHENS, IGNITION, S. GIBBONS, M. BRITTAIN

Baskets (Season 3) | FX Networks | Ignition

193 SILVER

TODD HEUGHENS, STEPHANIE GIBBONS 🇺🇸

Snowfall (Season 1) - Series | FX Networks | Iconisus

MARCOS MININI 🇧🇷

Organismo Kafka | Estúdio Delírio | Marcos Minini

YOUHEI OGAWA 🇯🇵

Nho GRATIA | DANCE WEST | OGAWAYOUHEI DESIGN DESK

HALUK TUNCAY 🇹🇷

Lemons,Lemons,Lemons.Lemons.Lemons | DOT Theatre | H.Tuncay

194 SILVER

NGADHNJIM MEHMETI

Women (GRATË) | The Albanian Theater Skopje | Eggra

STEPHAN BUNDI

Plan B | Theater Biel Solothurn | Atelier Bundi

STUDIO LONNE WENNEKENDONK

Theater Babel Rotterdam
Theater Babel Rotterdam | Studio Lonne Wennekendonk

VANJA CUCULIĆ

King Richard III, theatre poster
City drama theatre Gavella | Studio Cuculić

195 SILVER

CARMIT HALLER

Hamlet | Haller Metalwerks | Carmit Design Stduio

JAMES LACEY

Sunday in the Park with George
Revival Theatre Company | Dennard, Lacey & Associates

YOUHEI OGAWA

Nho Marie Antoinette
DANCE WEST | OGAWAYOUHEI DESIGN DESK

196 MEAGHAN A. DEE

The Sound of Silence | Typo-poetry: Despite Black and White in Sound | **Meaghan A. Dee**

197 SILVER

CURT RICE

Love of Type
Self-initiated | Landor

STEPHEN GUENTHER

CAPE SANTA MARIA | Beach Resort
Cape Santa Maria Beach Resort | Stephen Guenther

ALEX SETH

Typographics 2016
ArtCenter | Alex Seth

CHRISTOPHER LUECK, BRIANA LYNCH

Cruel Intentions: The Musical Poster
Cruel Intentions Worldwide, LLC | The Pekoe Group

198 SILVER

CARMIT HALLER

Broken Love
Haller Metalwerks | Carmit Design Studio

CARLOS PION

CHAVÓN OCTAVA PROMOCIÓN
25 AÑOS DESPUÉS

EIGHT GRADUATED DESIGN PROGRAM TWENTY FIVE YEAR LATER
ALTOS DE CHAVON SCHOOL OF DESIGN | CARLOS PION NEW YOK

THOMAS KÜHNEN & PHILLIP BERG

The Agony of Choice
Folkwang University of the Arts, Essen, NRW | Folkwang UdK

FA-HSIANG HU

May Your Good Work Be Rewarded
www.adlinktech.com

Lucky Numbers
ADLINK Technology Inc. | hufax arts

Honorable Mentions

200 HONORABLE MENTIONS

Markham & Stein 🇺🇸	Teak 🇺🇸	Tri-State G&T 🇺🇸	Zulu Alpha Kilo 🇨🇦
Underline Studio 🇨🇦	Stark Designs, LLC 🇺🇸	Cold Open 🇺🇸	Rose 🇬🇧
Elephant in the Room 🇺🇸	Zero-G Design 🇮🇳	Folkwang Uni. of the Arts 🇩🇪	MARK:MIL 🇯🇵
Studio Pekka Loiri 🇫🇮	Elephant in the Room 🇺🇸	FleishmanHillard 🇺🇸	Wieslaw Grzegorczyk 🇵🇱

201 HONORABLE MENTIONS

ADTRAN, Inc 🇺🇸	**Bob Delevante Studios** 🇺🇸
Tivadar Bote Illustration 🇨🇦	**Cold Open** 🇺🇸
Cold Open 🇺🇸	**Cold Open** 🇺🇸
ARSONAL 🇺🇸	**Cold Open** 🇺🇸
Cold Open 🇺🇸	**Concentric HX AD club** 🇺🇸
BEK Design and Consltancy 🇹🇷	**Chikako Oguma** 🇯🇵
InSync PLUS 🇺🇸	**Sommese Design** 🇺🇸
Pentagram 🇺🇸	**Alex Seth** 🇺🇸

202 HONORABLE MENTIONS

Recruit Comm. Co., Ltd.	🇯🇵
L.S. Boldsmith	🇨🇦
Parable Communications	🇨🇦
Braley Design	🇺🇸
Exit10	🇺🇸
Chemi Montes	🇺🇸
Tetsuro Minorikawa	🇯🇵
Savannah College of Art & Design	🇺🇸
Carmit Design Studio	🇮🇱
Braley Design	🇺🇸
Blue Collar Group	🇮🇱
ATS	🇰🇷
Finn Nygaard	🇩🇰
Genaro Design, LLC	🇺🇸
Bailey Lauerman	🇺🇸
Dalian RYCX Adver. Co., Ltd.	🇨🇳

203 HONORABLE MENTIONS

ARSONAL 🇺🇸	Pentagram 🇺🇸	Mueller Design 🇺🇸	TOKY Branding + Design 🇺🇸
Traction Factory 🇺🇸	ARSONAL 🇺🇸	Kibele Yarman 🇹🇷	anacmyk 🇵🇹
Takashi Akiyama studio 🇯🇵	School of the Art Inst. Mktg. Dept. 🇺🇸	Edik Boghosian Studio 🇦🇲	Justin Kemerling Design Co 🇺🇸
Ogilvy Portugal 🇵🇹	Daisuke Kashiwa 🇯🇵	ATS 🇰🇷	Ariane Spanier Design 🇩🇪

204 HONORABLE MENTIONS

Truth Collective 🇺🇸

Langrand 🇺🇸

Ted Wright Illustration & Design 🇺🇸

Melisa Z. Ozkan 🇺🇸

PICA Design Collective 🇺🇸

None 🇰🇷

ARSONAL 🇺🇸

Cepheid 🇺🇸

Elsenbach Design 🇩🇪

Design SubTerra 🇺🇸

Luis Antonio Rivera Rodriguez 🇲🇽

BRAND DIRECTORS 🇰🇷

Stoltze Design 🇺🇸

Internal MarCom Department 🇺🇸

HBakkali 🇪🇸

L.S. Boldsmith 🇨🇦

205 HONORABLE MENTIONS

Pica Design Collective	Selman Design	Ted Wright Illustration & Design	Markham & Stein
Schifino Lee	water with water	IF Studio	Bob Delevante Studios
Matt Luckhurst	DVL Seigenthaler	Carmit Design Studio	John Sposato Design & Ill.
Dennard, Lacey & Associates	COLLINS	Stoltze Design	COLLINS

206 HONORABLE MENTIONS

Martin French Studio	Carmit Design Studio	effiwerks	Monroe Creative Studio
Kate Resnick Design	Cold Open	Meaghan A. Dee	Langrand
Chemi Montes	studio'farrell	BEK Design and Consultancy	JAY
Shine United	Owen Gildersleeve Ltd.	The Pekoe Group	Virginia Tech

207 Honorable Mentions

Marcos Minini 🇧🇷	Marcos Minini 🇧🇷	The Pekoe Group 🇺🇸	21xdesign 🇺🇸
Langrand 🇺🇸	Langrand 🇺🇸	Marcos Minini 🇧🇷	Langrand 🇨🇦
Molly Tuttle Design 🇺🇸	Savannah College of Art & Design 🇺🇸	DVL Seigenthaler 🇺🇸	Behind the Amusement Park 🇸🇪
The Pekoe Group 🇺🇸	Faceout Studio 🇺🇸	Jason Wilkins 🇺🇸	Langrand 🇺🇸

208 HONORABLE MENTIONS

Jie-Fei design	Graphic Comm. Laboratory	Kaveh Haerian	BEK Design and Cunsultancy
Courtney Windham Design	Zulu Alpha Kilo	FleishmanHillard	KOJIMA DESIGN OFFICE inc.
Carmit Design Studio	Rule29 Creative	HBO LATIN AMERICA	Cepheid
FleishmanHillard	Mat Weller Design	Carmit Design Studio	Moniker

209 HONORABLE MENTIONS

Monroe Creative Studio 🇹🇷

Cushman Creative 🇺🇸

Teiichi Inoue 🇯🇵

Steiner Graphics 🇨🇦

Parasmo 🇺🇸

CommandSpace 🇺🇸

Savannah College of Art & Design 🇺🇸

Graphicha 🇰🇷

JAY 🇺🇸

Atelier Bundi AG 🇨🇭

Elephant in the Room 🇺🇸

Clavadetscher Gestaltung 🇨🇭

Karen Kresge Design 🇺🇸

STUDIO INTERNATIONAL 🇭🇷

Recruit Comm. Co., Ltd. 🇯🇵

Art Collart Office 🇳🇱

210 HONORABLE MENTIONS

JAY	Stephan Bundi	Markham & Stein	Molly Tuttle Design
David Bieloh Design	Justin Kemerling Design Co	FleishmanHillard	ScholarStat In-House Team
Zulu Alpha Kilo	xose teiga, studio.	Michael Schwab Studio	Traction Factory
Visual Arts Press, Ltd.	Hilppa Hyrkäs Design	Ellen Bruss Design	Selman Design

211 HONORABLE MENTIONS

unlikeable studio	Serve Marketing	Namseoul University	Kibele Yarman
Vadim Gershman	xose teiga, studio.	John Sposato Design & Ill.	Carmit Design Studio
Toyotsugu Itoh Design Office	Traction Factory	Kate Resnick Design	Mazzarium Inc.
Hoyne	Carmit Design Studio	COLLINS	Ten Gun Design

212 HONORABLE MENTIONS

Andrew Sloan 🇬🇧	FORUM_2017_poster.png 🇯🇵	Finn Nygaard 🇩🇰	Justin Kemerling Design Co 🇺🇸
Rozina Design 🇺🇸	Ariane Spanier Design 🇩🇪	Overdrive Design Ltd. 🇨🇦	Chikako Oguma 🇯🇵
Recruit Comm. Co., Ltd. 🇯🇵	studiotwentysix2 🇺🇸	Concentric AD club 🇺🇸	Molly Tuttle Design 🇺🇸
Brad Holland 🇺🇸	MUSE-UM.co	danielguillermo.com 🇺🇸	Justin Kemerling Design Co 🇺🇸

213 HONORABLE MENTIONS

Langrand 🇺🇸	Langrand 🇺🇸
Marlena Buczek Smith 🇺🇸	Total Identity, Bureau Visueel 🇳🇱
ThoughtMatter 🇺🇸	Dennard, Lacey & Associates 🇺🇸
Ted Wright Illustration & Design 🇺🇸	TOKY Branding + Design 🇺🇸
Christopher Scott Designer 🇪🇨	Thorbjørn Gudnason 🇺🇸
Molly Tuttle Design 🇺🇸	Gravdahl Design 🇺🇸

The secret to getting ahead is getting started.
Mark Twain, *Writer*

Always do your best. What you plant now, you will harvest later.
Og Mandino, *Author*

214 HONORABLE MENTIONS

Cold Open

Zulu Alpha Kilo

Cold Open

Hartwork

Savannah College of Art and Design

MAT

Bailey Lauerman

BVK

Shine United

studioKALEIDO

Carmit Design Studio

Carmit Design Studio

215 HONORABLE MENTIONS

Everybody has to start somewhere.
You have your whole future ahead of you.
Perfection doesn't happen right away.

Haruki Murakami, *Writer*

Eleven19

Hoyne

HBO LATIN AMERICA

Ryan Russell Deign

Shine United

IF Studio

TOKY Branding + Design

BVK

BVK

Credits & Commentary

217 CREDITS & COMMENTARY

PLATINUM WINNERS:

26 HOMAGE TO UMBERTO ECO | Design Firm: Rikke Hansen | Designer: Rikke Hansen
Client: BICeBé and National Museum of Art, La Paz

Assignment: Invitational International Poster exhibition in Homage to Umberto Eco. National Museum of Art, La Paz organised by the BICeBé. Poster created to honor Umberto Eco by mixing the erudite with the immediate, pairing philosophy and semiotics. Like Foucault´s pendulum, name given to his second novel, Eco reminds us that there is a centre – even if we are not able to perceive it. Everything rotates, the universe rotates, the world rotates and we spin along with the world, even if we feel our feet are firm as well as our goals.
Approach: Hand cut paper, big type made in letterpress and scanned for digital use, a combination of digital and crafting, and finally collected and built in photoshop. ■ Original size: 120x176 cm
Results: Exhibited at National Museum of Art, La Paz organised by the BICeBé 2017 ■ 3rd International Poster Biennale Lublin 2017, awarded with Honourable mention.

27 THE WOW TRIO | Design Firm: hofmann.to | Designer: Matthias Hofmann
Client: Neustahl GmbH

Assignment: Design a Poster for the jazz-concert of "The WOW Trio" at Neustahl's Souterrain Club in Luzern, Switzerland.
Approach: Bring the Music and Sounds of "The WOW Trio" to the point.

28 DESIGN IS FUTURE | Design Firm: hufax arts Co., Ltd. / C.U.T.e | Designer: Fa-Hsiang Hu
Client: China University of Technology

Assignment: A poster for China University of Technology Graduate Institute of Visual Communication Design to enroll new students in 2018.
Approach: How can visual communication design affect students and the general public? Perhaps we can only provide a correct direction to the future. ■ However, we are even more concerned with how to think correctly and create hands-on training. ■ Because visual communication design is nothing more than shape and color, fonts and graphics, content and form. If we can get inspired from these foundations, it is the purpose and glory of the Visual Communication Design Institute. ■ We believe that contemporary designers need to understand the past and create the future now. We use the basic shapes of colors in the admission posters of the School Research Institute to convey the imagination and desire for a better future for contemporary graphic design.
Results: We attracted more students interested in visual communication design. And establish a better professional image of China University of Technology Graduate Institute of Visual Communication Design.

29 TAMA ART UNIVERSITY DOCTORAL PROGRAM GRADUATION EXHIBITION
Design Firm: Takashi Akiyama Studio | Designer: Takashi Akiyama | Client: Tama Art University

Assignment: Poster for the announcement of an exhibition.
Approach: Bones in the body imagine problems and the image of the movement of a horse can get over the problem of knowledge.
Results: The exhibition was held from 8 to 23 March 2017 at Tama Art University Museum.

30 DER MIETER (THE TENANT) | Design Firm: Gunter Rambow | Designer: Gunter Rambow
Client: Oper Frankfurt | Creative Team: Angelika Eschbach-Rambow

Assignment: Opera by Arnulf Herrmann.
Approach: The Tenant feels threatened by the other tenants in the house, goes insane and jumps outside the window in the end—same as the tenant who lived in the flat before him.
Results: An eyecatcher to interest more people than ordinary opera fans.

31 THE EAST CUT LAUNCH POSTER SERIES | Design Firm: COLLINS
Designers: Erik Berger Vaage, Caroline Bagley, Christian Widlic | Client: The East Cut Community Board District | Strategy Director: Anna Sternoff | Senior Producer: Ashley Kasten Senior Designer: Christian Widlic | Lead Designer: Erik Berger Vaage | Design Director: David Minh Nguyen | Creative Director: Steve Reinmuth | Chief Creative Officer: Matt Luckhurst Artists: Apexer, Caroline Bagley, Jacob Bang, Ryan Bosse, Fnnch, Mary Finlayson, LA Hall, Andreas Helin, Aleya Hoerlein, Essen International, Math Times Joy, Ben Klein, Julia Lemke, Daniel Lindqvist, Terri Loewenthal, Matt Luckhurst, Casey Martin, Gabrielle Matte, Mitch Mauk, Moniker, David Minh Nguyen, Rasmus Nilsson, Neil Nisbet, Michael Osborne, Erik Otto, Mike Payne, Steve Reinmuth, Victor Reyes, David John Scott, Karin Soukup, Michael Stark, Michael Taylor, Evan Tolleson, Erik Berger Vaage, Carl Valin, Christian Widlic

Assignment: After developing the name and visual identity for the East Cut, a newly formed neighborhood in downtown San Francisco, we were tasked with finding an impactful way to announce and launch the new neighborhood to residents, community members, and the rest of city.
Approach: We chose to host an art show as the big launch event, showcasing the neighborhood's cosmopolitan spirit and new role as a cultural hub. Held in an event space in the heart of the neighborhood, the show would feature different artists' interpretations of the new East Cut symbol: a stacked 'E' form, to be reimagined, construed, and filled by them. We invited local artists and designers to submit their work to be displayed at the show and auctioned to attendees.
Results: The neighborhood art show featured 50 submissions from San Francisco artists, representing wildly diverse styles and techniques. The range of interpretations of the East Cut symbol demonstrated how the heart and spirit of the neighborhood is created by its members, and underscored the East Cut's dedication to public art and community engagement. Attendees included artists, residents, and workers from the neighborhood, as well as civic leaders. Posters were auctioned to attendees, who wanted to display their new distinctive icon of neighborhood pride. All proceeds went to the Community Benefit District, the group responsible for advancing the neighborhood's quality of life through public services, art, and culture.

32 2 MINUTES | Design Firm: Traction Factory | Designer: Peter Bell | Client: ALS Association Wisconsin Chapter | Production Artist: Christopher Dick Executive Creative Director: Peter Bell Copywriter: Jay Sanders | Account Services: Whitney Marshall | Account Director: Shannon Egan

Assignment: Create a poster inviting the community and potential donors to come together for a Kentucky Derby Viewing Party—with the purpose of raising awareness and funds for the ALS Association Wisconsin Chapter and local Multiple Sclerosis Chapter.
Approach: Design an emotive poster inviting the viewer into the world of the Kentucky Derby while also exposing them to an important social cause through the use of engaging typography and imagery.
Results: The poster raised awareness of this horrific disease and the second-year event raised over $10,000 with 125 people in attendance (up from prior year).

33 #NEVERAGAIN | Design Firm: 21xdesign | Designer: Patricia McElroy, Dermot MacCormack, Julie Lam | Client: Self-initiated | Illustrator: Julie Lam | Art Director: Patricia McElroy

Assignment: This poster joins a series of Anti-gun posters we have developed over the years. As part of this series, we want to bring attention to the issue of gun control in the US.

34 AHS: CULT | Design Firm: Bond/P+A/Ignition/Iconisus | Designer: FX Networks/Bond/P+A/Ignition/Iconisus | Client: FX Networks | Production: Lisa Lejeune (FX Networks) Photographer: Frank Ockenfels | Design Manager: Laura Handy (FX Networks) Creative Directors: P+A, Todd Heughens | Senior Vice President, Print Design, FX Networks: Todd Heughens | President, Creative, Strategy & Digital, Multi-Platform Marketing, FX Networks: Stephanie Gibbons | Art Directors: Michael Brittain, Rob Wilson (FX Networks) Vice President, Print Design, FX Networks: Michael Brittain

Assignment: Cult culture relinquishes individuality in favor of one leader.
Approach: This series explored the hive mind and bees, hexagons, patterns, immersion, and control. The resulting "hive" mentality creates the illusion of power as part of a larger purpose for the trapped individual and absolute power for the leader.

35 AHS: CULT – BEE EYES | Design Firm: Iconisus | Designer: FX Networks/Bond Client: FX Networks | Production: Lisa Lejeune (FX Networks) | Photographer: Frank Ockenfels Design Manager: Laura Handy (FX Networks) | Creative Directors: Bond, Todd Heughens, Stephanie Gibbons | Senior Vice President, Print Design, FX Networks: Todd Heughens President, Creative, Strategy & Digital, Multi-Platform Marketing, FX Networks: Stephanie Gibbons | Art Directors: Michael Brittain, Rob Wilson | Vice President, Print Design, FX Networks: Michael Brittain | Director, Print Design, FX Networks: Rob Wilson

Assignment: Same as above.

GOLD WINNERS:

38 HALLOWEEN | Design Firm: Zulu Alpha Kilo | Designer: Zulu Alpha Kilo
Clients: Harley-Davidson Canada, Jay Own, Vesa Mikkola | Writer: Coleman Mallery Print Producers: Laura Dubcovsky, Kari Macknight Dearborn | Printer: Flash Reproductions Illustrator: Nabil Elsaadi | Executive Creative Director: Allen Oke | Digital Artists: Brandon Dyson, Greg Heptinstall | Chief Creative Officer: Zak Mroueh | Associate Creative Directors: Andrew Caie, Noel Fenn | Art Director: Lisa Phuong | Account Director: David Tremblay

Assignment: The end of October is generally known for two things in Canada: Halloween and the end of riding season for motorcycle owners. It's typically a slow sales period, so we developed a unique retail initiative for Harley-Davidson that coincided with these dates to promote Harley-Davidson Genuine Parts and Merchandise with a Halloween theme.
Approach: Our Halloween-themed poster featured one of the most iconic sportster bikes, the Forty-Eight, showing every single one of its parts in the shape of a skull. This image had a double meaning to Harley riders as there was already an iconic skull synonymous with the brand – the Willie G Skull, designed in the early 1930's. The design payed homage to the long-respected badge, while being relevant to our theme and goal.
Results: The work was posted late October, 2017 in dealerships across Ontario, Canada, to encourage riders who fix their bikes in the off-season to use parts made exclusively for their bikes.

39 THE BMW COEXISTS WITH NATURE | Design Firm: HYUK-JUNE JANG
Designer: HYUK-JUNE JANG | Client: BMW

Assignment: The poster concept was created to deliver the message "BMW engine coexists with nature." At present, more people are suffering from fine dust. Environmental problems are becoming serious. I hope that this engine will enable people and nature to live without any pain.

40 BAYNA BODY CARE | Design Firm: SVIDesign | Designer: Sasha Vidakovic
Client: Ivancic i sinovi | Typographer: Sasha VidakovicStrategy and Naming: Sasha Vidakovic, Nada Ivancic | Illustrator: Sasha Vidakovic | Creative Director: Sasha Vidakovic

Assignment: Promote the launch of new body care brand and its handmade products
Approach: A pattern of hand drawn shapes is used to wrap the packaging like a skin. Juxtaposition of pattern on pattern creates an optically attractive effect to draw viewers' attention and stand out on the street.
Results: Recognition and reinforced visual personality of the new brand.

218 CREDITS & COMMENTARY

41 H + H / HUSMEE + HELVETICA | Design Firm: Husmee | Designer: Husmee | Client: 60th Anniversary Helvetica Typeface
Assignment: Husmee Studio has organised this project in order to pay tribute to the Helvetica typeface on its 60th anniversary. Each participant studio will create a poster related to this great typeface. ■ The tribute will be displayed online, creating a website in which the proposals will be seen. ■ www.60helvetica.com ■ #60helvetica ■ Participants: Atlas / Build / BVD ■ Empatía / Graphéine ■ Graphical House ■ Hey Studio / Husmee ■ Javier Mariscal / Mario Eskenazi / Mash Creative ■ Monumento (Ex Face) ■ Oscar Mariné / Patrick Thomas / Estudio ■ Pep Carrió / Socio ■ Design /Spin / Toko ■ Toormix / Waterhouse ■ Cifuentes Design ■ (Ex Vignelli Associates).
Approach: Represent the value of this typeface by designing a typographic poster in a visual, simple, and direct way with a clear Swiss style.
Results: We worked only with two basic elements, the red colour and the "H" letter (initial of Helvetica and Husmee), creating a hollow shape with the form of the plus-sign, which also creates the Swiss flag.

42 HOMAGE TO UMBERTO ECO | Design Firm: Gravdahl Design | Designer: John Gravdahl | Client: Bienal del Cartel Bolivia BICeBé
Assignment: International invitational poster tribute to the literary work of Umberto Eco. This was a satellite exhibition to the Bienal del Cartel Bolivia BICeBé in La Paz.
Approach: Using a reference to Eco's book Foucault's Pendulum integrated with a suggestion of the pages of a book in the process of disturbance and realignment as a metaphor for the events in the story.
Results: Exhibition occurred in La Paz Bolivia in 2017

43, 44 EVERYONE, EL SALVADOR | Design Firm: Underline Studio | Designer: Fidel Peña | Client: Self-initiated | Photographer: Paul Weeks | Creative Directors: Fidel Peña, Claire Dawson
Assignment: Create a campaign to raise funds for Pro-Búsqueda, a Salvadoran human rights association that searches for children who disappeared during the civil war.
Approach: Four posters that commemorate the victims of massacres that took place in El Salvador. Each poster uses poetry, drawing, and photography to confront some of the worst massacres in the country's history. The project was launched with a Kickstarter campaign.
Results: Awareness was raised about these issues though the campaign and media coverage. Also, 171 people supported the campaign and $7,000 CDN were raised for Pro-Búsqueda.

45 HOMAGE TO UMBERTO ECO 1932-2016 | Design Firm: Kari Piippo Oy | Designer: Kari Piippo | Client: The Biennial of Poster Bolivia BICeBé
Assignment: A tribute poster to Umberto Eco.
Approach: Umberto Eco was an Italian semiotician, linguist, philosopher, writer, and professor. ■ He was the pioneer of semiotic studies.
Results: Large-format posters were exhibited at the National Museum of Art in La Paz, Bolivia.

46, 47 FACEBOOK DATA CENTER SAFETY POSTERS | Design Firm: Stout SF | Designer: Ryan Meis | Client: Facebook
Assignment: Designed for display across Facebook's Data Center locations, this series was created to keep employees safe by calling attention to the potential dangers specific to the data center work environment. Bold, custom typography and large Greek gods and goddesses remind employees to use caution in the presence of hazardous equipment.
Approach: Create a compelling safety poster series using fun illustration and mythical characters that bring awareness to workplace safety topics.
Results: Colorful 18x24" silk-screened posters printed and hung throughout Facebook's data center locations that delight employees with awesome visuals and remind them of safety awareness.

48 「DESIGN DAY」 OF GRAPHIC ART SEMINAR IN KINDAI | Design Firm: Graphic Art seminar laboratory | Designer: kiyoung AN | Client: KINDAI university (Department of Arts)
Assignment: PR poster for the new year seminar of KINDAI University. This is represented Japan's symbol "Hinomaru" (sun), design "D," and sunshine as a motif. "Design Day" introduces and show that seminar design work and industry-university collaborative design.

49 DSVC GOLF TOURNAMENT POSTER | Design Firm: Jeremy Honea | Designer: Jeremy Honea | Client: Dallas Society of Visual Communications

50 15. MESSAGE ILLUSTRATION POSTER 2017 | Design Firm: Takashi Akiyama Studio | Designer: Takashi Akiyama | Client: Tama Art University Illustration studies
Assignment: The Message Illustration Poster Exhibition was started in 2000 and the 15th time was met.The purpose of the exhibition is to look for an expression of an illustration poster.
Approach: A work's theme is student's autonomy, Competition consciousness with a teacher and a student.
Results: The exhibition "Message Illustration Poster 2017" was held from 8 to 21 Sep 2017 at Design Gallery 1F of Tama Art University.

51 KINDAI UNIVERSITY, KIYOUNG AN VISUAL DESIGN SEMINAR PR POSTER
Design Firm: Graphic Art seminar laboratory | Designer: kiyoung AN | Client: KINDAI university
Assignment: Visual Design seminar PR poster for freshmen in the Department of Arts.

52 FARGO S3 | Design Firm: ARSONAL | Designer: ARSONAL / FX Networks | Client: FX Networks | Production Manager: Lisa Lejeune (FX Networks) | Photographer: ARSONAL Main Contributor: ARSONAL | Illustrator: ARSONAL | Design Manager: Laura Handy (FX Networks) | Creative Directors: ARSONAL, Stephanie Gibbons, Todd Heughens | President, FX Networks: Stephanie Gibbons | Senior Vice President, FX Networks: Todd Heughens | Art Director: ARSONAL, Keath Moon (FX Networks) | Agency: ARSONAL
Assignment: Create key art that continued the same homespun kitsch of the past two seasons' campaigns. The art should feel small town and handmade while incorporating unexpected elements of danger and crime.
Approach: We explored several different themes of the Fargo universe in general and also themes specific to this new third season. We found that stamp-themed art allowed us to incorporate interesting images and elements within the stamps themselves.
Results: The stamp sheet art falls entirely into the Fargo branding and color palette while itself being a central theme of the third season's plot. Each stamp features imagery and themes from both the show's setting and storyline in order to engage the audience to examine the stamps for clues as to what's coming next this season.

53 THE ASSASSINATION OF GIANNI VERSACE: AN AMERICAN CRIME STORY
Design Firm: InSync PLUS | Designer: InSync PLUS / FX Networks | Client: FX Networks | Production Manager: Lisa Lejeune (FX Networks) | Design Manager: Laura Handy (FX Networks) | Creative Directors: InSync PLUS, Stephanie Gibbons (FX Networks), Todd Heughens (FX Networks) | Art Director: InSync PLUS, Todd Russell (FX Networks)
Assignment: Create a strong follow up to the first installment of the American Crime Story Anthology that brings in the intense, striking colors of Miami 90's noir and utilizing symbols from the Versace brand.
Approach: We explored bold and intense color palettes, as well as the Medusa statue and other fine art imagery to invoke Versace's brand of glamour, beauty, and excess.
Results: The final poster was a close crop of Bernini's statue of Medusa, a nod to the icon of the Versace brand, treated with bold Miami inspired gel lighting tying back to both the eye-catching fashion of the decade.

54 RED SPARROW | Design Firm: InSync PLUS | Designer: Kishan Muthucumaru | Client: 20th Century Fox | Creative Director: Jeff Wadley
Assignment: Explore Key Art that portrays the character in a powerful and provocative way.
Approach: Playing up the mystery and thriller aspect of the storyline, we explored different ways of showing the character in empowering and strong ways including more iconic and conceptual executions.
Results: The final key art piece was a simple and yet bold portrait of a complex character using the strong red color, graphic element, and careful logo placement to draw the viewer into her eyes.

55 STAR WARS: THE LAST JEDI | Design Firm: InSync PLUS
Designers: Kishan Muthucumaru, Greg Soto | Client: Walt Disney Studios Motion Pictures
Chief Creative Director: Kishan Muthucumaru
Assignment: Show iconic aspects of the Star Wars franchise, both old and new.
Approach: We broke out individual elements of the Star Wars universe, and The Last Jedi in particular, into light and dark sides of the force. Placing each on a simple graphic background of color, each element becomes an icon. The classic elements help introduce and build excitement for the new, unfamiliar elements.
Results: The final poster shows eight light side and eight dark side elements. Topps trading cards were created for each individual piece, along with other promotional items.

56 HUNTER STREET - SEASON 2 | Design Firm: Cold Open | Designer: Cold Open | Client: Nickelodeon

57 THE HANDMAID'S TALE S1 | Design Firm: ARSONAL | Designer: ARSONAL | Client: HULU Photographer: Jill Greenberg | Main Contributor: ARSONAL | Creative Director: ARSONAL Copywriter: Paul Sopocy | Art Director: ARSONAL | Agency: ARSONAL
Assignment: For The Handmaid's Tale, Hulu was looking for provocative art that reflected the disturbing yet addictive nature of the show, without being too dark or depressing. They wanted to tap into the visual contradictions between the beautiful world of Gilead where things appear very normal, but on closer inspection, things are very off. The show also has an underlying humor via Elisabeth Moss' character's voiceover that they wanted to allude to in the art.
Approach: To reflect the juxtapositions of the storyline between beauty and horror, and submissiveness and resistance, we mined the scripts for visual cues and dialogue that told this story. The final pieces feature quiet, subdued character images set against more disturbing backdrops, with copy that captures the voice and tone of each character. The double read on the character campaign's copy is also a reflection of the duality in the settings and characters in the show.
Results: Hulu doesn't release ratings data, but the client was thrilled with the art. The show was immediately picked up for an additional season.

58 EDÉN | Design Firm: Scott Laserow Posters | Designer: Scott Laserow | Client: Segunda Llamada
Assignment: Create a poster on climate change to inform people that it is an urgent and significant threat, and remind them not to stay passively and indifferently in their comfort zones.

219 CREDITS & COMMENTARY

Approach: I wanted to create an image that reminds us how beautiful and fleeting nature can be. The planet is in trouble and we're denying it. I wanted the wilted flower to be dying, but still alive as a sign of hope.

59 LA CIUDAD LIGERA | Design Firm: Estudio Pep Carrió | Designer: Pep Carrió
Client: DIMAD/Ayuntamiento de Madrid | Photographer: Antonio Fernández

Assignment: On the occasion of Madrid Gráfica, a major annual event for graphic design in the capital of Spain, there were presented a wide selection of exhibitions and events. Also, an open call of posters for the exhibition La ciudad ligera (The Light City), which should reflect the future and sustainability of cities.
Approach: The slogan La ciudad ligera asked us for a unique solution to represent that idea. We photographed a model train figure on a real feather, expressing the ecological spirit of the proposal.
Results: The poster was selected by a jury from among the most outstanding and was exhibited in outdoor media in the city of Madrid.

60 OGAKI MATSURI FESTIVAL | Design Firm: Braley Design | Designer: Michael Braley
Client: Ogaki Matsuri Festival Competition

Assignment: Entry into the Ogaki Matsuri Festival poster competition. The festival is a 360 year old event that signals arrival of early summer to Ogaki, Japan and is made up of 13 "yama" parade floats featuring stages for "kabuki" child plays or "karakuri" marionettes dolls.

61 LUCY'S FRIED CHICKEN 7TH ANNUAL REVIVAL | Design Firm: Pentagram
Designer: Barrett Fry | Client: Lucy's Fried Chicken | Art Director: DJ Stout

Assignment: Poster for Lucy's annual event celebrating all things Texas, fried chicken and beer.
Approach: The typography for this year's poster was created using chicken bones from a bucket of Lucy's chicken.

62 ECLIPSE POSTER: PALE FIRE | Design Firm: TOKY Branding + Design
Designer: Ashford Stamper | Client: Self-initiated | Chief Creative Director: Eric Thoelke

Assignment: The Eclipse of 2017 was a once-in-a-lifetime event, and TOKY's headquarters in St. Louis happened to be in the path of totality. Our team designed posters celebrating the event.
Approach: "While thinking about this project, I was reminded of a few lines from one of my favorite books, Pale Fire. In its original context, it has nothing to do with an eclipse, but there's this notion of an epiphany momentarily connecting the writer to space and time. And historically, there has always been a sense of providence related to eclipses — something spiritual or otherworldly — like this extraordinary celestial coincidence can be a unifier between humanity and the rest of the universe."
/ Ashford Stamper

63 GREAT MANGART | Design Firm: Takashi Akiyama Studio | Designer: Takashi Akiyama
Client: Mangart Committee

Assignment: "Mangart" is a synthetic word of "art" and "manga." Mangart is the cartoonists' group formed in 1984. ■ 14 cartoonists participated in a exhibition this time.
Approach: The idea drew "The pen is mightier than the sword."
Results: The exhibition "Great Mangart" was held from 5 to 11 Sep 2017 at MOTOAZABU Gallery.

64 FIELDWORK: OBSERVATION & RECORD | Design Firm: DAEKI & JUN studio
Designers: Daeki Shim, Yonghoon Park | Client: Hyundai Card Design Library / Korea Craft & Design Foundation(KCDF) / Typojanchi | Art Director: Daeki Shim | Intern: Yonghoon Park

Assignment: Promote a design workshop on the topic 'Fieldwork: Observation and Record', which was held by the Hyundai Card Design Library and Typojanchi 2017—the 5th International Typography Biennale.
Approach: The following concepts and production were used as visual motifs to express the theme of the design workshop: 1) There is no right perspective. When two or more new perspectives interact with each other, their perspectives are changed, newly interpreted, and born. 2) When light enters through the lens, it reaches the inner retina and forms an image. When the stimulus is transmitted to the cerebrum through the nerve, an object is seen. 3) In order to maximize the above workshop concepts, silver foil printing technique was used. The silver foil printed image used in the poster changes in response to the view we see with the eye and the movement of the light. ■ The workshop was held at the Hyundai Card Design Library, conducted by a graphic designer, Daeki Shim, and assisted by an intern designer, Yonghoon Park. The starting point of the 'Fieldwork: Observation and Record' workshop is as follows: "In seeking new approaches for opening expansive spaces and awakening possibilities, let us look to our way of seeing themselves, and how, quite literally, the means to create perspective lies right between our eyes... there is a difference between the view each process - thus there is no single, "correct" view. This becomes evident by looking alternately through only one eye at a time and it is this displacement -parallax- which enables us to perceive depth. Our stereoscopic vision is the creation and integration of two views. Seeing, much like walking on two feet, is a constant negotiation between two distinct sources."
Results: The poster fits the ideas that the client wished to convey, to which the client was satisfied.

65, 66 SATELLITES SEASON 2017 | Design Firm: Alt Group
Designers: Dean Poole, Kennady Virak | Client: Auckland Council | Photographer: Toaki Okano
Design Director: Tyrone Ohia | Creative Director: Dean Poole

Assignment: Satellites is a platform that showcases Auckland's best Asian artists through performances, exhibitions, and unexpected encounters.
Approach: Focused on different Auckland suburbs, the programme includes a diverse series of experiences, including: a K-POP dance showdown in Botany, a Miss Changy breakfast experience in the Central City, Artham Dance Company in Sandringham, pocket art exhibitions in New Lynn and a Fortune Cookie Cart in locations across Auckland.
Results: With the goal of getting Auckland's Asian communities engaged in arts and culture, a campaign identity was developed to unify the events. Striking artist portraits give a face to each experience, and bold typography is paired with a unique linear element that connects the series.

67 INTERACCIONES | Design Firm: Yinsen | Designers: María Pradera, Lorena Sayavera
Client: ITC - Technology Center

Assignment: Interactions is the catchword of an Architectural and Interior Design Show held in the "Feria Hábitat Valencia." Some ceramic innovations of the moment are exposed, and also serve as a meeting point between professionals. The color gamut was defined by the client.
Approach: An interaction is a reciprocal action between two or more objects. Thinking in the technological character of the show, we look for the graphical representation of the interactions between physical elements, atoms, magnetism, etc. On the other hand, we examine the structure of the word Interactions to place it in a grid that allow us to play with the forms and the letters.
Results: It synthesizes with a few resources and transmits effectively the values and the mission of the client.

68 FORKA PROJECT | Design Firm: Center for Design Research | Designer: Eduard Cehovin
Client: Self-initiated

Assignment: FORKA PROJECT is a platform that includes creative activities that develop innovative approaches to research of the form, both in its formal form, and in the sense of its abstract expression, perception and understanding of the sensual, emotional, material and mental.
Approach: The motto THE MORE IS MORE, THEN LESS, is an important source for creative solutions.
Results: The mixing of different design genres, which would show the basic idea of a new approach in design, dedicated to very young artists.

69 SOLOTAGE | Design Firm: Fons Hickmann m23 | Designer: Fons Hickmann
Client: Neubad Luzern

Assignment: The Neubad is an old indoor swimming pool in Lucerne, Switzerland, where concerts and art events are held. Fons Hickmann designed the poster for the "Solotage Festival." Solotage is the german word for one-man show.

70 ARTS FESTIVAL | Design Firm: Sommese Design | Designer: Lanny Sommese
Client: Pennsylvania Festival of the Arts

Assignment: Design a poster for the Central Pennsylvania Festival of the Arts, an annual summer exhibition of the visual and performing arts held in State College, PA and the Penn State University campus. This is a project I've been doing annually for over the past 40 years.
Approach: I wanted to create a playful, exciting poster that featured elements of the performing arts.
Results: The result was a poster that was given out to festival goers, many of whom collect each poster annually.

71 WURZELN, KRONEN, HERBST (ROOTS, CROWNS, AUTUMN)
Design Firm: Gunter Rambow | Designer: Gunter Rambow | Client: HfG Karlsruhe
Text: Angelika Eschbach-Rambow | Creative Team: Angelika Eschbach-Rambow

Assignment: Poster for the 25th Anniversary of HfG Karlsruhe. Former members and professors were asked to design posters for a specific season, in this case autumn.
Approach: We show an X-ray of teeth in the "autumn" of life and therefore with some root canal treatment. Text is related to teeth and trees.
Results: Part of a permanent exhibition with other posters on same seasons theme (1 of 100).

72 1917-2017 | Design Firm: Gunter Rambow | Designer: Gunter Rambow
Client: Golden Bee Moscow

Assignment: Poster for 100 years anniversary Russian Sovjet Republik
Approach: Hammer and sickle are not in use any more and therefore I show them taken down.
Results: Part of web exhibition with other posters on same theme.

73 THE WIND | Design Firm: Tsushima Design | Designer: Hajime Tsushima
Client: Korea National University of Arts | Copywriter: Yukiko Tsushima

Assignment: Invitation poster design exhibition of 100 designers currently active in Japan, Korea, China was held with the theme of Asia's design as "New Wind blowing from East Asia." It is a poster for that exhibition.
Approach: Wind is one of the important natural phenomena that we are indispensable for humanity. ■ The wind continues to blow while giving great influence such as our lifestyle and way of thinking. ■ This poster is expressed as a new style of cultural exchange blowing from East Asia.

220 CREDITS & COMMENTARY

■ This is a kanji in Japanese and Chinese, writing as wind. ■ I made a typeface as a poster with a delicate image even in a powerful situation.
Results: An exhibition was held in Tokyo, Osaka, Jeju, Seoul, Beijing, Gwangju, Busan. This exhibition was co-sponsored by the university. Many people, including students, visited the exhibition.

74 RESONANCE 123456789 | Design Firm: Randy Clark | Designer: Randy Clark
Client: Asia Network Beyond Desig
Assignment: Design a series of posters surrounding the notion of Resonance nostalgia. This is one of my visual essays.
Approach: Locate imagery that speak to us, collectively and individually.

75 UBUNTU | Design Firm: Pirtle Design | Designers: Woody Pirtle, Lucas Pirtle
Client: Armando Milani
Assignment: Create a poster for an exhibition focused on the word UBUNTU, used frequently by Nelson Mandela in his lectures. The meaning is centered on compassion and humanity.
Approach: I incorporated an altered infinity symbol including 2 hearts to convey the meaning of the word.
Results: The poster was enthusiastically accepted by the client.

76 TAKASHI AKIYAMA POSTER NAKANOKUCHI | Design Firm: Takashi Akiyama Studio
Designer: Takashi Akiyama | Client: Nakanokuchi memorial hall one's predecessor
Assignment: I received request of an exhibition from The Nakanokuchi Senjinkan (Gallery of Nakanokuchi memorial hall of one's predecessor).
Approach: Among the predecessor of this hall, the sumo wrestler (Japanese national sports) HAGUROYAMA is famous. On the poster there is a scene where the two wrestlers are fighting. It is AKIYAMA and HAGUROYAMA with humor.
Results: The exhibition "Takashi Akiyama Poster Nakanokuchi" was held from 27 May to 25 june 2017 at senjinkan Gallery (Nakanokuchi memorial hall of one's predecessor).

77 JOÃO MACHADO ARTE DA COR | Design Firm: João Machado Design | Designer: João Machado | Client: MACNA - Museu de Arte Contemporânea Nadir Afonso
Assignment: This poster was requested by MACNA – Nadir Afonso Contemporary Art Museum in Chaves, Portugal to promote my individual exhibition 'João Machado Art of Color.'
Approach: The elements of the composition were chosen and related to my activity, synthesizing the use of color in my work.
Results: The exhibition ran from October 2017 to April 2018 and featured 200 posters, illustrations and sculptures made during the last 40 years of work. ■ In the context of this exhibition, was published a book.

78 BORDERS | Design Firm: Melchior Imboden | Designer: Melchior Imboden
Client: Invited AGI Poster Exhibition

79 RESONANCE ANGEL | Design Firm: Randy Clark | Designer: Randy Clark
Client: Asia Network Beyond Design
Assignment: Design a series of posters that reflect the Asian sensibilities of "resonance."
Approach: Immersed in the Chinese culture as a foreigner, the history and traditions are not lost on me. China is beautiful, almost beyond description. The citizens of China are always reflecting back to the past, to their rich tapestry of being holistically, and uniquely, Chinese.
Results: I've received a number of requests for reprints of these posters.

80 IMAGERY OF SOCIAL MEDIA | Design Firm: Dankook University | Designer: Hoon-Dong Chung | Client: The language of war and peace in the new media | Art Director: Hoon-Dong Chung
Assignment: This work is intended to symbolically represent 'Imagery of Social Media.'
Approach: This work features combining concentration and dispersion in order to dynamically highlights the symbolic aspect of 'Imagery of Social Media.'
Results: This got good reviews on the design field and awards.

81 SIXTO JUAN-ZAVALA: VISITING ARTIST, SCHOLAR AND DESIGNER
Design Firm: Shawn Meek & Sixto Juan-Zavala | Designers: Shawn Meek, Sixto Juan-Zavala
Client: Metropolitan State University of Denver
Assignment: As part of Metropolitan State University's annual Visiting Artist, Scholar and Designer program, Sixto-Juan Zavala (Austin, TX) was invited to a two-day workshop and lecture series with undergraduate Communication Design students in Fall 2017. The poster was to advertise these involvements as well as promote the lecture at the Center for Visual Art.
Approach: The design needed to encapsulate the designer's sensibilities, which reflect interest in juxtapositions of culture, art, and gender identity. By using encapsulated elements within the design, the feeling of intrigue and interest yielded a level of anticipation for students to learn more about the designer's evocative approach to design.
Results: The poster promoted not only the designer, but also the event details for student(s) involvement. The poster was displayed at various venues in the Denver market for promotion and received high reviews by Metropolitan State University of Denver's Department of Art's Communication Design program and the Center for Visual Art.

82 UBUNTU | Design Firm: MAT | Designer: Mehmet Ali Türkmen | Client: Armando Milani
Approach: For Armando Milani's "Ubuntu" poster project. The word "Ubuntu" that means humanity, dialogue, empathy, sharing, koiné, respect, sustainability, support, tolerance and solidarity is a word that Mandela uses very often. ■ Design idea: "Being" is being with another. Man becomes conservative and wild if he confines himself to himself, feeds on himself and remains within his own territory. Uncovering himself to one another, on the other hand, makes him strong, healthy and happy, and enriches him.

83, 84 2017 VANCOUVER WRITERS FEST | Design Firm: Carter Hales Design Lab Inc.
Designer: Sean Carter | Clients: Vancouver Writers Fest | Production Manager: Joanne Henderson | Production Artist: Miles Linklater | Illustrators/Designers: Rosie Gopaul, Sherry Jang, Andrew Schick, Benjamin Stone, Tony Yu | Account Director: Stuart Freer
Assignment: Create a poster that communicates the variety of writers that will be presenting at the 2017 Writers Fest.
Approach: A campaign of six posters was designed to express the diversity of each guest's experience and how the written and spoken word makes one reimagine their world. ■ All six custom illustrations are based on themes and books found at the 2017 Festival.

85, 86 BEYKOZ KUNDURA RESTORED FILM DAYS | Design Firm: Monroe Creative Studio
Designer: Dogukan Karapinar | Client: Beykoz Kundura | Project Manager: Elif Abidinoglu
Creative Director: Onur Gokalp
Assignment: Istanbul's first Restored Film Days took place in August, bringing cinema classics to an audience in the uniquely beautiful atmosphere of the Kundura Fabrikası. The Kundura Fabrikası, an old industrial complex, was the perfect location for the Restored Film Days. Our assignment was to create posters to promote the festival and get the attention of cinema lovers.
Approach: We created a rich visual style which uses cult movie characters to use on posters on streets and other applications on the location. Our aim was to reflect and fuse the repetitive nature of a factory and classic movies which is re-aired thousand times.
Results: All tickets were sold out before the event started. And the first time festival got a lot of attention on the media.

87 CINANIMA | Design Firm: João Machado Design | Designer: João Machado
Client: Nascente Cooperativa de Acção Cultural, CRL
Assignment: Cinanima is an international animation film festival organised by NASCENTE - Cooperative Society and Espinho's City Hall every year, during the month of November. Since its first edition in 1977, I've been doing all the posters for this Festival.
Approach: The figure of the juggler symbolizes the filmmaker. He's an artist who plays with dreams, in this case the movie tapes.

88 FOTOGRAMAS / FRAMES | Design Firm: Husmee | Designer: Husmee
Client: San Sebastian International Film Festival
Assignment: Cartel para el 65º Festival Internacional de Cine de San Sebastián.
Approach: The poster should generate rhythm and different compositions for all the formats used. We wanted to create a series of graphic elements that would form not just a poster, but a complete graphic.
Results: The poster is divided into a grid generating 24 'frames' telling a story starring the number 65, with different cuts and frames that change as the graphics unfold. The compositions are not chronological, but play with the cut and editing concept. Using this element enables them to generate rhythm and different compositions for all of the formats used.

89 GAUDEAMUS MUZIEKWEEK 2017 | Design Firm: Studio Lonne Wennekendonk
Designer: Studio Lonne Wennekendonk | Client: Gaudeamus Muziekweek
Assignment: Design the announcement poster for Gaudeamus Muziekweek 2017.
Approach: To address an international public in a unique way, the announcement poster intends to give contemporary music a special form of expression. This is brought by incorporating concrete forms with associative meanings. The colorful shell of the beetle catches your eye while it dances in the void. But what happens when you flip the button?
Results: The surprise effect of the design ensures that the announcement of the festival is perceived among the visual information flood of an urban environment.

90 ASGARD VOYAGER BEER POSTER | Design Firm: Ventress Design Works
Designer: Tom Ventress | Client: Asgard Brewing Company | Illustrator: Tom Ventress
Assignment: This poster originally began as a packaging design, but the packaging project was delayed until spring of 2018. The client liked this design, though, and wanted to use it as banners to enrich the decor of the taproom and beer hall.
Approach: "Voyager" suggested a Viking sailing ship to us. The sail and bow of the illustrated ship are based on historically accurate reference material. We felt strongly that the figurehead needed to be unique to set it apart from any other and took liberties with the traditional perception of Viking figureheads to create a distinctive design.
Results: "Everybody loves this" is what the client told us.

221 CREDITS & COMMENTARY

91 BOTTLE CAP FLAG | Design Firm: Angry Dog | Designer: Rafael Fernandes
Client: Nippon Beverages

Assignment: This poster was developed for the launch of Nippon Bebidas, brazilian importer of japanese drinks.
Approach: Japanese community in Brazil numbers almost 2 million people. Most of them live in São Paulo and are potential consumers of Nippon Bebidas products. Our great challenge was creating a strong idea with communication potential and especially with low production cost. It had to be something clear, understood immediately. ■ Our inspiration was the japanese flag, an obvious but also very powerful reference.
Results: At first the poster should be used only at the client's headquarters, but they liked it so much that it became part of an advertising campaign.

92 CREATIVE CONNECTIONS | Design Firm: Braley Design | Designer: Michael Braley
Client: AAF Cedar Rapids / Iowa City

Assignment: Poster promoting Braley's presentation in his hometown of Cedar Rapids, Iowa.

93 20TH DÜSSELDORF INTERNATIONAL ENDOSCOPY SYMPOSIUM | Design Firm: Elsenbach Design | Designers: Nicole Elsenbach, Helmut Rottke, Wiebke Windhagen | Client: COCS GmbH - Congress Organisation C. Schäfer and Prof. Dr. Horst Neuhaus

Assignment: For the 20th birthday of the Endoscopy Symposium the client wanted to build on the motives that had been used in the past years but which would fit to the anniversary.
Approach: The poster shows insights into the human body seen through an endoscope. For the past years round pictures on black background had been used to advertise for this event. This year we created 20 balloons from endoscopic pictures to celebrate the birthday.
Results: Just like the symposium, the poster gives doctors a new perpective at their field of work. This poster has even become a collector's item among the participants of the symposium.

94 GLOBALOCAL | Design Firm: Ariane Spanier Design | Designer: Ariane Spanier
Client: Kunsthalle zu Kiel

Assignment: Poster for a contemporary art exhibition at the Kunsthalle zu Kiel, Kiel, Germany, with local artists from the museum's collection and 3 invited international artists.
Approach: Typographical "globe-like" interpretation of "globalocal" as a circle filled with the letters combining the words "global" and "local."
Results: A strong colored typographic poster in 2 Pantone colors that worked well in the public places it was put up in the northern German city of Kiel, where February is usually a grey month.

95 OGAKI MATSURI FESTIVAL | Design Firm: João Machado Design
Designer: João Machado | Client: Ogaki Poster Museum

Assignment: This project has been requested by the organization of the Ogaki Matsuri Festival, Japan, which traditionally celebrates the arrival of summer in Japan.
Approach: The topics suggested by the organization itself regarding Japanese traditions and beliefs. My choice was the carp. It's a fish that assumes several mythical meanings in Eastern culture. It is a sign of good luck, virility (blue carp) wisdom, and endurance. The legend tells that the carp to spawn had to reach the source of the river Huang Ho. The fish had to swim against the current, overtaking waterfalls to the Jishinhan mountain. The one that reached the top would become a dragon. It is believed that the carp in uphill position means strength, courage, and determination to achieve goals and overcome difficulties.
Results: The poster decorated the main streets of Ogaki during the period in which this festival took place. Limited editions of serigraphs were also produced on the genuine Mino paper.

96 OH WOW | Design Firm: studio lindhorst-emme | Designer: Sven Lindhorst-Emme
Client: Weserburg Museum for modern Art, Bremen and University of the Arts, Bremen
Client Support: Ingo Clauß, Curator Bremen, Ana Baumgart

Assignment: Design a Poster and a publication for the "Meisterschüler"-class (Masters of Arts) from the University of Arts in Bremen.
Approach: I wanted to create something that takes sign between all the other posters, so I decided to use that psychedelic view of the Title "OH WOW," on every media in a different way.

97 100 YEARS OF THE RUSSIAN REVOLUTION 1917–2017 | Design Firm: Melchior Imboden | Designer: Melchior Imboden | Client: Invitational poster exhibition

98 THE CLOCHE | Design Firm: Fons Hickmann m23 | Designer: Fons Hickmann
Client: Neubad Luzern

Assignment: Designed for a performance by Leipzig-based band The Cloche, whose music alternates between high-powered beats and spherical sounds, blending electronic music and jazz.

99 ST. PAUL & THE BROKEN BONES | Design Firm: Braley Design | Designer: Michael Braley
Client: St. Paul & The Broken Bones

Assignment: Poster for St. Paul and The Broken Bones show at the Lexington Opera House Nov 15 & 16, 2017 in Lexington, Kentucky. St. Paul and The Broken Bones is a six-piece soul band based in Birmingham, Alabama. 18 x 24 in. Silk Screen. Limited edition of 50.

100 MAC DEMARCO | Design Firm: THERE IS Studio | Designer: THERE IS Studio
Client: Another Planet Entertainment

Assignment: Create a special edition gig poster for notoriously goofball musician Mac DeMarco.
Approach: We wanted to create something playful and somehow trashy, and came up with this idea of some bol type filling the canvas made of bubble gum, with bits chewed, and those beautiful stringy bits connecting some of the letters & a nice bubble for the "O." For good measure, we added loose teeth falling behind and in front of the lettering—some kind of tribute to his signature look. The whole thing was made out of good old chewed classic bubble gum, lots of sticky business & dribble bits – a nice real-life pink mess made by hand & photographed.
Results: Happy client + Sold Out Poster.

101 VAN MORRISON | Design Firm: THERE IS Studio | Designer: THERE IS Studio
Client: Another Planet Entertainment

Assignment: We were commissioned by Another Planet Entertainment to create a limited edition gig poster for music icon Van Morrison.
Approach: We came up with the idea of a full page typographic design, mixing a classic font with a more contemporary layout, unified with dimensional flourishing flowing through the the lettering—forming a sculptural metallic composition.
Results: Happy client + Sold Out poster.

102 2ND ACADEMY CONCERT | Design Firm: Ariane Spanier Design | Designers: Ariane Spanier, Stephie Becker | Client: Musikalische Akademie Mannheim

Assignment: Poster for the 2nd concert of a classical concert series "Academy concerts." The numbers of the concerts (8) per season are designed out of musical notes.
Approach: The posters for the orchestra's concert series interprete classical music in different ways, while the number and a color always are a fixed element assigned to each concert. For this season 2017/2018 romantic landscape paintings accompanying the concert posters.
Results: The posters are very well-perceived in the city of Mannheim and the region. They changed the visual landscape and visually the orchestra got a very strong place in the public eye.

103 COSI FAN TUTTE | Design Firm: Gunter Rambow | Designer: Gunter Rambow
Client: Oper Frankfurt | Creative Team: Angelika Eschbach-Rambow

Assignment: Opera by Wolfgang Amadeus Mozart.
Approach: We relate to the cheerful and dancing atmosphere, colors are related to the scenery.
Results: An eyecatcher to interest more people than ordinary opera fans.

104 BILLY BUDD | Design Firm: Gunter Rambow | Designer: Gunter Rambow
Client: Oper Frankfurt | Creative Team: Angelika Eschbach-Rambow

Assignment: Opera by Benjamin Britten.
Approach: Billy Budd is a young sailor who will be hanged in the end of the opera without being guilty. The rope spiral is his fate, leading to his bitter end.
Results: An eyecatcher to interest more people than ordinary opera fans.

105 THE MERRY WIDOW (GERMAN: DIE LUSTIGE WITWE) | Design Firm: Atelier Bundi AG
Designer: Stephan Bundi | Client: Theater Orchester Biel Solothurn

Assignment: The rich, young widow defends herself against intrigues and seeks true love.

106 PETER GRIMES | Design Firm: Gunter Rambow | Designer: Gunter Rambow
Client: Oper Frankfurt | Creative Team: Angelika Eschbach-Rambow

Assignment: Opera by Benjamin Britten.
Approach: The apprentice of fisherman Peter Grimes gets lost in the sea and all people think that Grimes is guilty. In the end, Grimes gets lost himself in the sea.
Results: An eyecatcher to interest more people than ordinary opera fans.

107, 108 CHRIS BUZELLI SVA SUBWAY POSTERS | Design Firm: Visual Arts Press, Ltd.
Designer: Chris Buzelli | Client: School of Visual Arts | Senior Designer: Ryan Durinick
Illustrator: Chris Buzelli | Executive Creative Director: Anthony P. Rhodes
Creative Director: Gail Anderson

Assignment: The Subway Series, started in the mid-1950s, invites faculty members—all practicing professionals—to showcase their talents, reach new audiences, and promote SVA.
Approach: BFA Illustration faculty member, Chris Buzelli, was chosen to create these posters. Buzelli has illustrated New York City animals to grab attention on the NYC Subway platforms.
Results: Buzelli's three urban critter ambassadors are represented in unique ways to inspire subway riders' creativity.

109 BODY & TYPOGRAPHY: 3RD PRE-SEMINAR & TALK
Design Firm: DAEKI & JUN studio | Designers: Daeki Shim, Hyojun Shim | Client: Korea Craft & Design Foundation(KCDF), Typojanchi 2017 | Art Directors: Daeki Shim, Hyojun Shim

Assignment: The poster announces the 3rd seminar & talk of the event for Typojanchi 2017 - the 5th International Typography Biennale.
Approach: The poster announces the 3rd seminar & talk of the event for the 5th International Typography Biennale, Typojanchi 2017. The topic of the 3rd seminar & talk is the 'process of work.' Speakers talk about

222 CREDITS & COMMENTARY

the process of their design projects. The visual motif used on the poster, the rectangle, is gradually shifting to the circle, and the plane letters B and T are becoming three-dimensional. This is a representation of the process by which design tasks gradually change from the beginning to the end stage. Also, the alphabets 'B' and 'T' used here are the theme of Biennale, 'Body and Typography.'
Results: The poster fits the ideas that the client wished to convey and satisfied them. ■ Size: 39.3 inch x 27.5 inch / 1000mm x 700mm).

110 JOÃO PACKAGE MACHADO DESIGN | Design Firm: João Machado Design
Designer: João Machado | Client: Self-initiated
Assignment: This poster belongs to a series of posters developed in the scope of some individual exhibitions that I have been doing recently (my posters, logos, and design in general).
Approach: Each one of the posters has to do with various areas of development of my work. I used the illustration of each letter that gives name to the various design fields that I develop (Posters, Packaging, Logos, Stamps...) ■ I drew and built the letter P in three dimensions as if I were drawing the final layout of the packaging with the same shape.

111 USS MOBILE | Design Firm: Red Square | Designer: Jordan Kabalka
Client: Austal USA | Account Supervisor: Elena Freed
Assignment: Mobile-based Austal USA is an industry-leading defense contractor that designs and manufactures the most advanced warships on the planet. In 2017, the U.S. Navy honored our fair city by naming the 26th littoral combat ship USS Mobile (LCS 26). Austal, in turn, tapped Red Square to develop a campaign to raise awareness of the ship, the company and its workforce, and our hometown on a global stage.
Approach: During our initial design exploration, the client mentioned their goal was to have kids hang our work on their bedroom wall, just like they would a movie poster. We approached the project with this in mind, developing a dramatic yet modern feel. The art needed to display the power of a combat ship and demonstrate that it is the true leader of the sea. We chose an illustrated look, rather than photo-realism, to add visual interest and to allow us to explore and refine the clean angles of the ship.
Results: The campaign features this theatrical poster, as well as collectable coins, stickers, and other materials to support events including the first cut, keel laying, launch, sea trials, delivery, and commissioning. The ship's deployment is set for 2021.

112 BIBLIOTECA PALERMO "CASA PÁJARO" | DESIGN FIRM: ESTUDIO PEP CARRIÓ
DESIGNER: PEP CARRIÓ | Client: Artes Gráficas Palermo | Photographer: Antonio Fernández
Assignment: Casa pájaro (House bird) poster is a project for Artes Gráficas Palermo, a printing house specialized in high quality art and photography books. ■ Each year, they publish a poster and promotional material around the idea of book.
Approach: A warm image, a bird nesting in a book house, a metaphor of the care that Artes Gráficas Palermo put in their editions. ■ The image was handmade of wood and then photographed.
Results: A motivating image that is added to other proposals created with books and already compose a collection: La Biblioteca Palermo.

113 GAYSHA | Design Firm: Behind the Amusement Park
Designers: Johan Ressle, Helene Havro | Client: TAK
Assignment: TAK arranged a Pride festival party in Stockholm and wanted a Japanese-inspired concept for their celebration.
Results: Artwork using the pride colours in a discrete way to celebrate the Pride festival party at the Japanese restaurant TAK in Stockholm.

114 LA CIUDAD LIGERA / THE LIGHT CITY | Design Firm: Braley Design
Designer: Michael Braley | Client: Madrid Grafica
Assignment: Poster selected as top 100 in "Madrid Gráfica" competition and will be exhibited both at La Ciudad Ligera / The Light City exhibition at Central de Diseño / Matadero Madrid. The competition was created to raise awareness for issues concerning urban transportation in Madrid and to inspire a new culture of mobility.

115 THE WORLD WITHOUT SURVEILLANCE! | Design Firm: Namseoul University
Designer: Byoung-il Sun | Client: ISHR International Society for Human Rights
Assignment: This poster is designed for Ukraine's 4th Block Triennial.
Approach: It is an image that hopes for a society that is safe even in the darkness, a society without surveillance, with overlapping descriptions of people and cats.
Results: This exhibition will be exhibited in Ukraine from April.

116 GOLF TOURNAMENT | Design Firm: FleishmanHillard | Designer: Buck Smith
Client: Self-initiated
Assignment: FleishmanHillard holds a corporate golf tournament every year with proceeds benefiting a local charity. They needed a poster to advertise the event and recruit golfers.
Approach: The goal was to portray golf in a unique way, to gain the attention of everyone, from golfers to people who typically weren't interested in playing in the tournament. Inspired by Bauhaus poster design the sun, flag and golf ball are represented by simple shapes on a sky-blue background.
Results: A large number of employees registered to play, many who were not passionate golfers. Even people who were not interested in playing in the tournament commented on the posters, which was something that never happened in the past.

117 HAMLET | Design Firm: Carmit Design Studio | Designer: Carmit Design Studio
Client: Haller Metalwerks

118 SHORELINE | Design Firm: Hoyne | Designers: James Fitzgerald, Peter Georgiou
Client: Made Property Group
Assignment: Shoreline by Made Property Group presented a rare opportunity to live right on the beach in Sydney's iconic surfing suburb of Manly. Hoyne was briefed to create a compelling campaign, including a poster, that would speak to a target audience of beach loving owner occupiers and locals who already knew and loved the area. The key challenge was to avoid a clichéd vision of Manly, and instead to create a campaign that was nuanced and focused on the exclusivity of the offering.
Results: The image articulates the exclusivity of the lifestyle on offer, where every day, at a certain hour, you can have one of the world's most beautiful beaches all to yourself.

119, 120 555 COLLINS | Design Firm: Hoyne | Designer: Nick Fels | Client: Fragrance Group
Assignment: Designed by award-winning architects Bates Smart, 555 Collins is located on Melbourne's most iconic street, known for its grand Victorian architecture and high-end retailers. The architecture promises to transform 555 Collins into an icon of the Melbourne skyline, with strong, sculpted and sophisticated lines and a tapered building base.
Approach: The posters leverage the Collins St location, proximity to luxury boutiques as well as the premium, luxury nature of the development itself. Subtle linear and curved elements mimic the cut of precious stones, emphasising scarcity and limited nature of the product and reflecting the architecture of the building.
Results: These strong yet simple set of posters align with luxury brands to attract and resonate with the target market.

121 EPICURE | Design Firm: Hoyne | Designers: James Fitzgerald, Pete Georgiou
Client: Changfa
Assignment: Epicure is a new development of 139 apartments in the inner-west Sydney suburb of Leichhardt. Leichhardt is an established community of heritage homes and boutique apartments, with local residents who do not readily welcome new development into their neighbourhoods.
Approach: To appeal to the local owner-occupier, we created a poster that leveraged the re-emerging character of Leichhardt and positioned Epicure as leading the renaissance of the area. Inspired by the area's Italian heritage, it communicated to locals a return to the international style and charm Leichhardt was once famous for—generous space to entertain family and friends and intimately connected to great food and culture; a return to 'La Dolce Vita.'
Results: The posters were vital in establishing Epicure as a place that contributes to the rich culture of Leichhardt, engaging the local community and successfully integrating the project into the fabric of the suburb.

122 DETAILS | Design Firm: IF Studio | Designers: Hisa Ide, Toshiaki Ide
Client: Brack Capital Real Estate | Stylist: Carin Sheve | Producer: Athena Azevedo
Photographer: Max Zambelli | Design Director: Hisa Ide
Creative Directors: Hisa Ide, Toshiaki Ide | Copywriter: Sarah Tan | Art Director: Kumiko Ide

123 OBJECTS | Design Firm: IF Studio | Designers: Hisa Ide, Toshiaki Ide
Client: Brack Capital Real Estate | Stylist: Carin Sheve | Producer: Athena Azevedo
Photographer: Max Zambelli | Design Director: Hisa Ide
Creative Directors: Hisa Ide, Toshiaki Ide | Copywriter: Sarah Tan | Art Director: Kumiko Ide

124 LASCELLES | Design Firm: Hoyne | Designers: Ruby Aitken, Nick Fels | Client: Techin
Assignment: Lascelles is a group of 55 luxury apartments by developer Techin, located in Melbourne's prestigious eastern suburb of Toorak. The posters had to represent the timeless, exclusive and prestigious nature of the product, and instil confidence in our educated buyer audience.
Approach: The brochure showcased the premium nature of the product and highlighted the craftsmanship involved in the architecture, interiors and finishes. They amplify stories about open green spaces and the superior design that buyers could expect. The overall style was theatrical and moody, which served the dual purpose of giving the imagery a premium feel and making the product appear like a showpiece on display.
Results: The campaign successfully appealed to the target market, ensured Lacelles' position among the highest ranks of Melbourne's new developments, and established Techin in Australia's luxury market.

125 1917-2017 | Design Firm: dnkstudio | Designer: Mykola Kovalenko
Client: Golden Bee Moscow
Assignment: GLOBAL POSTER CAMPAIGN "1917-2017"
Approach: 100th anniversary of the October Revolution in Russia

126 + - = | Design Firm: STUDIO INTERNATIONAL | Designer: Boris Ljubicic
Client: Self-initiated
Assignment: Politicians make decisions difficult because they have to

223 CREDITS & COMMENTARY

accept controversial proposals—the result of all political elections.
Approach: + - = ■ Where is the problem: plus, minus, just as a political-mathematical problem. ■ The mathematical formula + and - the result is = the basic idea in making political decisions.
Results: + - = ■ Mathematicians plus, minus and equally shape their faces, and the eyebrows serve to make no mistake in their decision, because the decisions must be transparent!

127 RESIST | Design Firm: Gravdahl Design | Designer: John Gravdahl
Client: Posters for Peace
Assignment: Invitational poster exhibition held in USA and Iran to express support for international peace efforts.
Approach: Objects of war and of peace integrated to send a message of "peace over war."
Results: Exhibitions held in USA and Iran in 2017.

128 HOME SWEET HOME | Design Firm: Pentagram | Designer: Jeffrey Wolverton
Client: "We the People" project | Art Director: DJ Stout
Assignment: Original poster for the "We The People" project initiated by Thoughtmatter, Mirko Ilić, and The Constitutional Sources Project.
Approach: Poster reinterprets the Third Amendment, which protects U.S. citizens from the government's "quartering" of soldiers in private homes.

129 DELETING IN PROGRESS | Design Firm: Marlena Buczek Smith
Designer: Marlena Buczek Smith | Client: Self-initiated
Assignment: To raise awareness and represent the issue effectively.
Approach: War is a very complicated process. ■ Even when achieving a desired outcome, when the fighting ends, it does not necessarily signify winning. One can win the war but lose peace.
Results: Posters can not solve the epidemic problems but can help with building awareness.

130 TERRORISM | Design Firm: begum gucuk | Designer: begum gucuk | Client: Self-initiated
Approach: A social awareness work about terrorism. The tragic effect of terrorism on humanity and the global struggle for peace.

131 1917–2017 (100 YEARS RUSSIAN REVOLUTION) | Design Firm: Atelier Bundi AG
Designer: Stephan Bundi | Client: Golden Bee Moscow
Assignment: Poster created at the invitation of the Moscow Golden Bee Biennale commemorating the centennial of the Communist Revolution.
Approach: The changed communist symbol.
Results: Poster for the Exhibition "1917–2017."

132 DESIGN TO UNITE | Design Firm: studio'farrell | Designers: deklah polansky, Tom Farrell
Client: DESIGN TO UNITE
Assignment: DesignToUnite challenged creatives to lend their support, voice, and creativity to design a poster calling for solidarity with Australia's First Peoples using the word 'Unite' to deliver a powerful statement about their importance and their right to a fair and just society.
Approach: Embed the Aboriginal flag into the key meaning of the word UNITE to create a direct and compelling word-as-image visual that will cut through in Ad-shel channels and deliver a thoughtful and evocative message to a broad audience.
Results: Multiple posters by designers were created and submitted to the DesignToUnite initiative to help the cause of Australia's First Peoples.

133 THE EVOLUTION OF THE CANDLELIGHT PROTESTS IN SOUTH KOREA
Design Firm: Oregon State University | Designer: Jun Bum Shin | Client: Self-initiated
Assignment: The poster is about the evolution of the candlelight protests in South Korea late 2016 – early 2017.
Approach: Background: Hundreds of thousands with candlelights rallied in central Seoul on November 25, 2016 for a fifth week of protests against President Park Geun-hye in the largest ongoing series of demonstrations in the country since the 1987 movement to democratize South Korea. Organizers of the rally estimated that there were over sixteen million participants in the protests over a period of five months. (The protests went through March 2017.) ■ It was largely peaceful, as were previous rallies, with songs and speeches striking a festive tone mixed with angry calls for her to quit. ■ On December 9, 2016, President Park was impeached by parliament over a corruption scandal. ■ I used a moving image of candlelight in the protest and designed with a Chinese letter 民本主義, which means democracy. The main theme represents the civil rights movement in South Korea.
Results: It is representative of the power of the civil rights movement and peaceful pretests in South Korea.

134 HUMAN RIGHTS | Design Firm: Tomaso Marcolla | Designer: Tomaso Marcolla
Client: Poster for Tomorrow | Author: Tomaso Marcolla
Assignment: The poster was created to celebrate the 70th Anniversary of the Universal Declaration of Human Rights.
Approach: The poster, entitled "Human Rights," is the image of a fish wrapped in a sheet of paper on which the Universal Declaration of Human Rights is printed. It is not used for its purpose to enforce human rights. This means that there is still no full respect for the rights for all and in many cases the Declaration is waste paper.

Results: An invitational poster project, with the support of the Office of the United Nations High Commissioner for Human Right (OHCHR) and La Mairie de Paris. The goal was of course to celebrate 70th Anniversary of the Universal Declaration of Human Rights.

135 EMP(A)T(H)Y | Design Firm: Rikke Hansen | Designer: Rikke Hansen | Client: Speak UP
Assignment: Poster—EMP(A)T(H)Y. Invitational Poster for SPEAK UP – Dangerous world now, better world tomorrow. ■ The world is beginning its most dangerous stage for decades. From the global refugee crisis to the spread of terrorism, our collective failure to resolve conflicts is engendering new threats and emergencies. Even in peaceful societies, the politics of fear is provoking a dangerous polarisation and demagogy.
Approach: I never will understand how extremist groups like Boko Haram and Isis, among others, can do what they do. You must be extreme cold hearted without any empathic feelings at all, to be able to rob, rape, and murder like we witnesses in recent times. ■ HUMANS ARE UNLIKELY to win the animal kingdom's prize for fastest, strongest or largest, but we are world champions at understanding one another. This interpersonal prowess is fueled, at least in part, by empathy: our tendency to care about and share other people's emotional experiences. Empathy is a cornerstone of human behavior and has long been considered innate. A forthcoming study, however, challenges this assumption by demonstrating that empathy levels have been declining over the past 30 years. ■ The goal is create awareness of the declining level of empathy, and what will be left in our hard and minds.
Results: Exhibited at the Speak up exhibition, together with 50 international designers, Mexico City, autumn 2017

136 BLACK BENTO | Design Firm: Tsushima Design | Designer: Hajime Tsushima
Client: Japan Graphic Designers Association Hiroshima | Photographer: Takeshi Shimizu
Creative Director: Yukiko Tsushima
Assignment: It is a peace poster for the Peace Poster Exhibition to be held annually in Hiroshima. It is also a PR poster of a catalog published in commemoration of the 20th work of the appeals poster being held from 1983.
Approach: This lunch box is stored in Hiroshima Peace Memorial Museum. I think that a lunch box is a symbol of love and peace. I wish for a peaceful desire to resonate in the hearts of many people.
Results: I think that this poster has conveyed a message of peace to many.

137 GLOBAL WARMING | Design Firm: Number8 Creative Inc. | Designer: Kei Sato
Client: Self-initiated | Art Director: Kei Sato
Assignment: We should play an active role against global warming.

138 NEIGHBORS RESPECT | Design Firm: Braley Design | Designer: Michael Braley
Client: Third Open All-Russian Poster Competition
Assignment: Poster selected for the: Third Open All-Russian Poster Competition / Russia: "The Third Path" 2017. "Have a respect for your neighbor's feelings and thoughts." D.S. Likhachev.

139 DISARMAMENT | Design Firm: Marlena Buczek Smith | Designer: Marlena Buczek Smith
Client: Self-initiated
Approach: Free world of nuclear weapons.
Results: Posters can not solve the epidemic problems but can help with building awareness.

140 DESERTIFICATION OF A TREE | Design Firm: Wesam Mazhar Haddad
Designer: Wesam Mazhar Haddad | Client: Self-initiated
Approach: Concept: Every tree we cut now is a desert of tomorrow. ■ Philosophy: Simplicity is the highest level of complexity; Complexity is the highest level of simplicity. ■ Execution: The chopped trunk of a tree is entirely composed out of sands. Days of computer graphics and retouching were implemented to achieve the final metaphor while keeping the features of a chopped trunk respectfully. Moreover, the typography is formed out of sands to reflect the fragility of our decisions that once we make them, we can't take them back.

141 MASS START | Design Firm: Freelance | Designer: Sol Bi Doo
Client: 2018 PyeongChang Olympic
Assignment: To describe Winter Olympic in PyeongChang (South Korea), and express victory and passion of Korea. It describes a moment of 'mass start,' which is a new event of speed skating in the Olympics.
Approach: Designed a dynamic atmosphere with flat illustration by using primary colors, various shapes, bold lines, and dots. The skaters are colored by five colors from the Olympic mark and added repetitive dots for more emphasis. For the background, I reinterpreted the flag design of South Korea to show a host country of winter Olympics in 2018.
Results: Without color and any description on the skaters' face, the poster conveys that everyone has the right to enjoy Olympic sports no matter who they are. Moreover, since the poster is colored vividly, it could catch eyes of the audience and provoke their interest.

142 MEET ME AT DOWN | Design Firm: H.Tuncay Design | Designer: Haluk Tuncay
Client: DOT Theatre | Director of Photography: Serdar Tanyeli
Approach: A woman trying to get in contact with her friend by hallucinating who dies in an accident... ■ A play in the matter of friendship.

143 BIEDERMANN UND DIE BRANDSTIFTER (THE FIRE RAISERS) | Design Firm: Atelier Bundi AG | Designer: Stephan Bundi | Client: Theater Orchester Biel Solothurn

Assignment: Play by Max Frisch. ■ Mr. Biedermann grants an unemployed man accommodation. Biedermann ignores obvious evidence that his guest is an arsonist.
Approach: If you have arsonars in your house, you need an extinguisher

144 HUMAN EAR | Design Firm: H.Tuncay Design | Designer: Haluk Tuncay | Client: DOT Theatre | Photographer: Serdar Tanyeli

Approach: A play about loneliness.

145 TERROR | Design Firm: Atelier Bundi AG | Designer: Stephan Bundi | Client: Theater Orchester Biel Solothurn

Assignment: Play by Ferdinand von Schirach. ■ A passenger aircraft is kidnapped with the aim of crashing it into a sold-out arena. How can the safety of the audience be ensured?
Approach: How can I show Last-Minute and security.
Results: Winner of the Swiss Poster Award, Gold.

146 MANON IN MANHATTAN KEY ART POSTER | Design Firm: The Pekoe Group | Designer: Briana Lynch | Client: GlobalMusicDrama LTD | Project Coordinator: Richard Pham | Creative Director: Christopher Lueck | Art Producer: Jason Murray

Assignment: To create a show poster for the new musical, Manon in Manhattan based off the novel, Manon Lescaut by Abbé Prévost. ■ The story unveils the passion, the power, the danger—the very forces that wield the destiny of the leading characters.
Approach: We layered New York City's cityscape, mood, and energy with the shows primary love story as a guide to our creative concept.
Results: The final piece reflects the mysterious and sexy nature of the show.

147 SONG ABOUT HIMSELF | Design Firm: Langrand | Designer: Spencer Strickland | Client: The Catastrophic Theatre | Chief Creative Director: Ray Redding

Assignment: Create imagery that explores what it's like to only be able to communicate in the most mundane and fragmentary ways.
Approach: Taking inspiration from how we do and don't communicate in the internet age, the artwork eludes to a corrupted and crumbling connection to humanity.
Results: Sold-out season performance dates.

148 A CHRISTMAS CAROL | Design Firm: Atelier Bundi AG | Designer: Stephan Bundi | Client: Theater Orchester Biel Solothurn

Assignment: By Patrick Barlowe after Charles Dickens
Approach: Christmas and ghosts.
Results: Poster, program and card.

149 SNOW WHITE | Design Firm: Langrand | Designer: Spencer Strickland | Client: The Catastrophic Theatre | Chief Creative Director: Ray Redding

Assignment: Create imagery that explores the risks and rewards of that universal and eternal subject—love.
Approach: Inspired by the work of Donald Barthelme, the postmodern novelist and poet, the artwork depicts Snow White gazing over a collected, curious bouquet as she waits for her prince.
Results: Sold-out performance dates. In addition, the play was reviewed in national media prior to the world premier.

150 MACBETH | Design Firm: Carmit Design Studio | Designer: Carmit Haller | Client: Haller Metalwerks

Assignment: Macbeth's vicious cycle of guilt is represented by washing the blood off the hands.

151 CREATIVE PROCESS POSTER Design Firm: TOKY Branding + Design | Designer: Kelcey Towell | Client: Creative Process/St. Louis Fashion Fund | Chief Creative Director: Eric Thoelke

Assignment: Create an identity and signature style for one of St. Louis Fashion Fund's signature events: Creative Process. The speaker series highlights the diverse creative ventures happening in St. Louis through celebrating and fostering cross-disciplinary collaborations.
Approach: The "stitched" typography brings the concepts of overlapping industries to the forefront. The designer even attempted to hand-stitch letters; it eventually evolved into vectored hand-drawn type.
Results: While ultimately not chosen as the design solution for this client's particular challenge, the TOKY team is extremely proud of this concept.

152 STOUT TYPOGRAPHIC POSTERS | Design Firm: Stout SF | Designers: Jordan Cullen, Ryan Bosse | Client: Self-initiated

Assignment: Self-authored studio posters that showcase bold typography through shapes and line work.
Approach: Create bold typographic posters by using the visual tension between shapes, lines, and minimal colors. A cohesive poster set that showcases the fine talents and tastes of design studio Stout SF.
Results: Bold and beautiful typographic posters screen printed with silver ink on black and metallic papers. Printed large scale at 24"x36".

153 BEST WISHES | Design Firm: hufax arts Co.,Ltd./ CUTe | Designer: Fa-Hsiang Hu | Client: TPDA | Chief Creative Officer: Alain Hu

Assignment: Promotion for Exhibition topic of TPDA.
Approach: Designed for annual topic of TPDA "words." Through festivals, we communicate each other's wishes through dialogue.

SILVER WINNERS

156 ARCHITEKTUR AUS WIEN: ÜBERZEUGEND ANDERS | Design Firm: Atelier Bundi AG | Designer: Stephan Bundi | Client: Architektur Forum Bern

156 GEBERIT ARKITERA ARCHITECTURE TRAVEL SCHOLARSHIP | Design Firm: Monroe Creative Studio | Designer: Emirhan Akyuz | Client: Geberit | Project Manager: Elif Abidinoglu | Creative Director: Onur Gokalp

156 THE NEW MOSCOW | Design Firm: Dizaino Studija Baklazanas | Designer: Irina Goryacheva | Client: Center of Russian Avant-garde | Project Manager: Alexander Kutcenko

156 AUDI HERITAGE POSTER SERIES | Design Firm: TracyLocke | Designers: Anthony Franzino, Kevin Forister, Nick Kidd | Client: Audi of America | Group Creative Director: Sherri Krekeler | Creative Director: Glen Day | Chief Creative Officer: Michael Lovegrove

157 DAS RENN TREFFEN POSTERS 2017 | Design Firm: Markham & Stein | Designer: Markham Cronin | Client: Das Renn Treffen

157 LUMINE LIFE IS JOURNEY | Design Firm: OUWN | Designer: ATSUSHI ISHIGURO(OUWN) | Client: LUMINE CO.,LTD. | Stylist: ARISA TAKEDA | Production: JR Higashi Nihon Kikaku | Producer: RISA UEDA | Illustrator: HIKARU ICHIJYO(OUWN) | Creative Director: ATSUSHI ISHIGURO(OUWN) | Animator: SHUJI DAITO | Agency: TRANSIT CREW INC.

157 AIGA FOUNDERS | Design Firm: Warkulwiz Design Associates | Designer: Bob Warkulwiz | Client: AIGA Philly 35th Anniversary

157 CHE GUEVARA 1928-1967 | Design Firm: Kari Piippo Oy | Designer: Kari Piippo | Client: Universidad Autónoma Metropolitana

158 50CHE | Design Firm: João Machado Design | Designer: João Machado | Client: Universidad Autónoma Metropolitana Mexico

158 CCA GALA HONORING DAVID KELLEY | Design Firm: Aufuldish & Warinner | Designer: Bob Aufuldish | Client: California College of the Arts | Illustrator: Kathy Warinner

158 60TH ANNIVERSARY HELVETICA TYPEFACE | Design Firm: Estudio Pep Carrió | Designers: Pep Carrió, Sandra Tenorio | Client: Husmee Studio Graphique! | Photographer: Antonio Fernández

158 NO SPEC POSTERS | Design Firm: Zulu Alpha Kilo | Designer: Zulu Alpha Kilo | Client: Self-initiated | Writers: Jacob Pacey, Jon Taylor | Studio: Brandon Dyson, Ashleigh OBrien | Retouching: Brandon Dyson | Print Producer: Christina Hill | Chief Creative Officer: Zak Mroueh | Art Directors: Brendan McMullen, Andrea Romanelli

159 SPRING DANCE WORKS 2017 | Design Firm: Purdue University | Designer: David L. Sigman | Client: Purdue Contemporary Dance Company | Photographer: David L. Sigman

159 STEM CLASSROOM POSTER | Design Firm: VEX Robotics in-house studio | Designer: Brian Delaney | Client: VEX Robotics, Inc. | Graphic Designers: Elizabeth Magana, Maddie Cordts, Magan Preas, Christine Gutierrez, Selena Granado, Antonio Martinez

159 KINDAI UNIVERSITY GRAPHIC ART & DESIGN COURSE PR POSTER | Design Firm: Graphic Art Seminar Laboratory. | Designer: kiyoung AN | Client: KINDAI university

159 100 VIEWS OF TAMA ART UNIVERSITY-4 / DESSIN-7 100 VIEW-TREE | Design Firm: Takashi Akiyama studio | Designer: Takashi Akiyama | Client: Tama Art University Dessin Project

160 RUNAWAYS - CHARACTER SERIES | Design Firm: Cold Open | Designer: Cold Open | Client: Hulu

160 DESTINY 2 | Design Firm: Petrol Advertising | Designer: Petrol Advertising | Client: Activision | Developer: Bungie

160 DESTINY 2 | Design Firm: Petrol Advertising | Designer: Petrol Advertising | Client: Activision | Developer: Bungie

161 MIND FIELD - SEASON 2 | Design Firm: Cold Open | Designer: Cold Open | Client: YouTube Red

161 ATLANTA S2 | Design Firm: ARSONAL | Designer: ARSONAL / FX Networks | Client: FX Networks | Production Manager: Lisa Lejeune (FX Networks) | Photographer: Matthias Clamer | Design Manager: Laura Handy (FX Networks) | Creative Directors: ARSONAL, Stephanie Gibbons, Todd Heughens, Michael Brittain | President (FX Networks): Stephanie Gibbons | SVP (FX Networks): Todd Heughens | VP (FX Networks): Michael Brittain | Art Director: ARSONAL, Todd Russell (FX Networks)

161 TOP CHEF S15 | Design Firm: ARSONAL | Designer: ARSONAL | Client: Bravo | Illustrator: ARSONAL / Jesse Vital | Creative Director: ARSONAL, Marcello La Ferla (Bravo) | Art Director: ARSONAL

161 THE STRAIN S4 | Design Firm: ARSONAL | Designers: ARSONAL, FX Networks | Client: FX Networks | Production Manager: Lisa Lejeune (FX Networks) | Photographer: Michael Becker | Design Manager: Laura Handy (FX Networks) | Creative Directors: ARSONAL, Stephanie Gibbons, Todd Heughens | President (FX Networks): Stephanie Gibbons | SVP (FX Networks): Todd Heughens | Art DIrectors: ARSONAL, Keath Moon (FX Networks), Paul V D'Elia (FX Networks)

162 PENDELTON RODEO DAYS | Design Firm: Ted Wright Illustration & Design | Designer: Ted Wright | Client: Pendelton | Illustrator: Ted Wright

162 THE LEGENDARY JOHNNY CASH | Design Firm: Ted Wright Illustration & Design | Designer: Ted Wright | Client: The Johnny Cash Museum/Nashville | Illustrator: Ted Wright

162 A GREAT BIG TEXAS HOWDY | Design Firm: Ted Wright Illustration & Design | Designer: Ted Wright | Client: Brian Houser | Illustrator: Ted Wright

162 EL HIPNOTIZADOR | Design Firm: HBO Latin America | Designer: HBO Latin America | Client: Self-initiated

162 THOROUGHBREDS - KEY ART | Design Firm: ARSONAL | Designer: ARSONAL | Client: Focus Features | Photographer: Claire Folger | Creative Director: ARSONAL, Blair Green (Focus Features) | Copywriter: ARSONAL | Art Director: ARSONAL

163 DARKEST HOUR - KEY ART | Design Firm: ARSONAL | Designer: ARSONAL | Client: Focus Features | Photographer: Jack English | Creative Director: ARSONAL, Blair Green (Focus Features) | Copywriter: ARSONAL | Art Director: ARSONAL

163 CALL OF DUTY: WW2 | Design Firm: Petrol Advertising | Designer: Petrol Advertising | Client: Activision | Developer: Sledgehammer Games

163 LINDSEY STIRLING: BRAVE ENOUGH | Design Firm: Cold Open | Designer: Cold Open | Client: YouTube Red

225 CREDITS & COMMENTARY

163 DARKEST HOUR - TEASER | Design Firm: ARSONAL | Designer: ARSONAL
Client: Focus Features | Photographer: Jack English | Creative Director: ARSONAL, Blair Green (Focus Features) | Art Director: ARSONAL

164 OUT OF SIGHT OUT OF MIND – E-WASTE IS NOT SOMEBODY ELSE'S PROBLEM
Design Firm: Rikke Hansen | Designer: Rikke Hansen | Client: BICeBé

164 LEAVING IMPRESSIONS | Design Firm: Superunion | Designer: Scott Lambert
Client: Singapore Parks | Creative Director: Dan Ellis | Typographer: Jei Ni Liew
Design Director: Scott Lambert | Design Associate: Ben Ong

164 HOMAGE TO UMBERTO ECO | Design Firm: Daisuke Kashiwa
Designer: Daisuke Kashiwa | Client: The Biennial of the Poster Bolivia BICeBé

164 ROADTRIP TO PANDO | Design Firm: Braley Design | Designer: Michael Braley
Client: Pando Populus | Account Director: Kate Davis

165 HONKER | Design Firm: Dalian RYCX Advertising Co., Ltd. | Designer: Yin Zhongjun
Client: Poland Auschwitz international political Poster Biennale

165 WATER AND POWER BLITZ | Design Firm: Braley Design | Designer: Michael Braley
Client: Pando Populus | Account Director: Kate Davis

165 22ND JFACE ANNUAL CONFERENCE | Design Firm: imageon CO., LTD.
Designer: Naoyuki Fukumoto | Client: Japanese Academy of Facial Studies

165 SHASTA CAMERA FUND | Design Firm: Michael Schwab Studio
Designer: Michael Schwab | Client: Shasta Ventures

166 CAMPANDO MARYKNOLL | Design Firm: Braley Design | Designer: Michael Braley
Client: Pando Populus | Account Director: Kate Davis

166 THE FUTURES OF DEATH ALLEY | Design Firm: Braley Design
Designer: Michael Braley | Client: Pando Populus | Account Director: Kate Davis

166 ARTS FESTIVAL | Design Firm: Sommese Design | Designer: Lanny Sommese
Client: Pennsylvania Festival of the Arts

166 LGBTQ MIXER | Design Firm: Penrose 300 | Designer: Kelly Holohan, Paul Kepple
Client: AIGA Philadelphia | Photographer: Kelly Holohan, Paul Kepple

167 PENDELTON WAY OUT WEST | Design Firm: Ted Wright Illustration & Design
Designer: Ted Wright | Client: Pendelton | Art Director: Greg Hatten

167 7TH ASSEMBLY OF RDA | Design Firm: Stavitsky Design | Designer: Vitaly Stavitsky
Client: Russia Designers Association (RDA) | Photographer: Olesa Tseytlin

167 IRODORI TEA PARTY | Design Firm: Chikako Oguma | Designer: Chikako Oguma
Client: Nihonbashi Mitsukoshi

168 THE GARDENER'S MARKET POSTER 2017 | Design Firm: Design SubTerra
Designer: R.P. Bissland | Client: Cache Valley Gardener's Market Association
Foundry: Borges Lettering | Chief Marketing Officer: Mary Laine

168 JEFF TALKS: MELİKE TAŞCIOĞLU | Design Firm: Gonca Koyuncu
Designer: M. Gonca Koyuncu | Client: Manifold

168 SO-CA SALON VOL. 1 | Design Firm: studioKALEIDO | Designer: Winnie Wu
Client: School of Clay Arts

168 THE GREAT DUMBO DROP | Design Firm: Selman Design | Designer: Selman Design
Client: The Dumbo Improvement District

169 PECHA KUCHA 29 | Design Firm: Pentagram | Designer: Haley Taylor
Client: Pecha Kucha Austin | Art Director: DJ Stout

169 GLOBAL CITIZEN NYC CONCERT POSTER | Design Firm: Emerson, Wajdowicz Studios
Designers: Jurek Wajdowicz, Manny Mendez | Client: Global Citizen
Art Director: Jurek Wajdowicz

169 ECLIPSE MYTHS | Design Firm: TOKY Branding + Design | Designer: Justin Striebel
Client: Self-initiated | Chief Creative Director: Eric Thoelke

170 V | Design Firm: studio lindhorst-emme | Designer: Sven Lindhorts-Emme
Client: R. - Raum für drastische Maßnahmen | Client Support: Sandy Becker

170 THIS IS A PUBLIC WALL! (AIXÒ ÉS UNA PARET PÚBLICA!)
Design Firm: David Torrents | Designer: David Torrents | Client: Marc Martí

170 BEAUTIFUL DOKDO | Design Firm: Woosuk University | Designer: Mi-Jung Lee
Client: Ministry of Culture, Sports and Tourism

170 BODY | Design Firm: Norikyuki Kasai | Designer: Norikyuki Kasai | Client: JAGDA Hokkaido

171 FRANZ KAFKA METAMORPHOSIS | Design Firm: Fons Hickmann m23
Designer: Fons Hickmann | Client: Posterbiennal Mexico

171 CSX FFA POSTERS | Design Firm: Exit10 | Designers: Rachel Ventura, Emilee Beeson
Clients: CSX Transportation, John Kitchens, CSX | Illustrator: Alaska S. Kellum
Creative Director: Scott Sugiuchi | Copywriter: Reese Cassard
Chief Creative Officer: Jonathan Helfman | Art Director: Emilee Beeson | Account Services: Jenna Shugars | Account Director: David White

171 POSTGRADUATE ILLUSTRATION STUDIES, GRADUATE EXHIBITION 2017
Design Firm: Daisuke Kashiwa | Designer: Daisuke Kashiwa
Client: Illustration Studies, Tama Art University

171 LIFE—LINDA RITOH, THE EXHIBITION WITH PHOTOGRAPHERS, 2017, OSAKA
Design Firm: Libido inc.& Linda Graphica | Designer: Linda Ritoh | Client: Heiwa Paper Co., Ltd / Paper Voice | Photographers: Koichi Okuwaki (series 2/7, 3/7), Tomohiko Moriyama (series 4/7, 5/7), Yoshiyuki Mori (series 6/7, 7/7) | Artist: Linda Ritoh (Objects) | Art Director: Linda Ritoh

172 RESONANCIA | Design Firm: Randy Clark | Designer: Randy Clark
Client: Asia Network Beyond Design

172 BERUF (OCCUPATION) | Design Firm: MAT | Designer: Mehmet Ali Türkmen
Client: Westend Fotoschule, Bremen

172 POSTER EXHIBITION FOR THE SOLILOQUY OF WORD | Design Firm: Leo Lin Design
Designer: Leo Lin | Client: Taiwan Poster Design Association

172 THE MODERN CHAIR | Design Firm: Eugene Lee | Designer: Eugene Lee
Client: The Museum of Modern Art | School: School of Visual Arts | Instructor: Carin Goldberg

173 36TH GMK GRAPHIC DESIGN EXHIBITION | Design Firm: Dilara Sebnem Esendemir
Designer: Dilara Sebnem Esendemir | Client: GMK Graphic Designers AssociationTurkey

173 MOTHER | Design Firm: Jie-Fei design | Designer: Jie-Fei Yang
Client: Strelka Design Biennale competition

173 POSTERS WITHOUT BORDERS EXHIBITION | Design Firm: Finn Nygaard
Designer: Finn Nygaard | Client: Art at the University of Alabama at Birmingham

173 NOVAS GLÓRIAS | Design Firm: João Machado Design | Designer: João Machado
Client: Clube Criativos de Portugal

174 JAZZ IN THE RUINS | Design Firm: Doğan Arslan | Designer: Doğan Arslan
Client: Jazz W Ruinach

174 CINANIMA | Design Firm: João Machado Design | Designer: João Machado
Client: Nascente Cooperativa de Acção Cultural, CRL

174 41ST PORTLAND INTERNATIONAL FILM FESTIVAL | Design Firm: Sandstrom Partners
Designer: Molly Kennedy-Darling | Client: Northwest Film Center | Illustrator: Always With Honor
Creative Director: Steve Sandstrom

174 SCAD ANIMATIONFEST | Design Firm: Savannah College of Art and Design
Designers: Divna Bileva, Jennifer McCarn | Client: Self-initiated | Writer: Frank Ricci
Vice President: Eleanor Twiford | Sr. Creative Service Director: Heather Athey
Project Manager: Caitlin DePue Wallace | Production Designers: Art Edel, Erin Williams
Editor: Connie Woods | Art Director: Melanie Prisco

175 SCAD GAMINGFEST | Design Firm: Savannah College of Art and Design
Designer: Divna Bileva | Client: Self-initiated | Writer: Frank Ricci | Vice President: Eleanor Twiford | Sr. Creative Service Director: Heather Athey | Project Manager: Chris Miller | Production Managers: Erin Williams, Art Edel, | Editor: Connie Woods | Art Director: Jennifer McCarn

175 BARD ON THE BEACH REBRANDING | Design Firm: Carter Hales Design Lab Inc
Designers: Sherry Jang, Chelsea Palmer | Client: Bard on the Beach

175 MOSCOW FILM FESTIVAL | Design Firm: BANKOVPOSTERS | Designer: Peter Bankov
Client: MIEF company

175 PREMIO DE NOVELA GRÁFICA CIUDADES IBEROAMERICANAS
Design Firm: Estudio Pep Carrió | Designer: Pep Carrió
Client: UCCI Unión de Ciudades Capitales Iberoamericanas | Photographer: Antonio Fernández

176 WALL | Design Firm: LaMachina Design Co. | Designer: Jorge Pomareda
Client: Chicago Latino Film Festival

176 RIVERRUN INTERNATIONAL FILM FESTIVAL RARE FINDS | Design Firm: Elephant In The Room | Designer: Will Hackley | Client: RiverRun International Film Festival

176 THE PINK GLASSES MURDERER | Design Firm: Charit Art Co.,Ltd.
Designer: Charit Pusiri | Client: Ardel

177 LECTURE ANNOUNCEMENT: LUTHER AND THE PLACES OF REFORMATION
Design Firm: Henning Kreitel | Designer: Henning Kreitel
Client: Zentral- und Landesbibliothek Berlin

177 TERRAS GAU | Design Firm: João Machado Design | Designer: João Machado
Client: Terras Gauda Francisco Mantecón

177 JINGLE ALL THE WAY - WILLIAMS SONOMA | Design Firm: Ted Wright Illustration & Design | Designer: Ted Wright | Client: Williams Sonoma - California | Art Director: Dawn Janney

178 WTMD RADIO FIRST THURSDAY CONCERT | Design Firm: Kaveh Haerian
Designer: Kaveh Haerian | Client: WTMD Radio

178 YES NAKED - CD ALBUM | Design Firm: SVIDesign
Designer: Sasha Vidakovic | Client: Naked | Typographer: Sasha Vidakovic
Creative Director: Sasha Vidakovic | Artist: Sasha Vidakovic

178 MONK 100 | Design Firm: Martin French Studio | Designer: Martin French
Client: Self-initiated

178 SHADDOX / MULLIGAN POSTER | Design Firm: Molly Tuttle Design
Designer: Molly Tuttle | Client: Billy Shaddox & Dave Mulligan

179 MINIMALISMUS+ | Design Firm: Monroe Creative Studio | Designer: Emre Kizildelioglu
Client: Kabak&Lin | Creative Director: Onur Gokalp | Art Director: Emirhan Akyuz

179 OUTSIDE LANDS POSTER | Design Firm: Owen Gildersleeve Ltd.
Designer: Owen Gildersleeve | Client: Another Planet Entertainment & Superfly

179 JAZZ KICKS BAND PLAY STRAYHORN | Design Firm: Design SubTerra
Designer: R.P. Bissland | Client: Jazz Kicks Band | Foundry: Filmtype, Monotype
Chief Creative Director: Larry Smith

179 DER FLIEGENDE HOLLÄNDER | Design Firm: Venti caratteruzzi | Designer: Carlo Fiore
Client: Accademia Nazionale di Santa Cecilia

180 IL TROVATORE | Design Firm: Gunter Rambow | Designer: Gunter Rambow
Client: Oper Frankfurt | Creative Team: Angelika Eschbach-Rambow

180 DER FLIEGENDE HOLLÄNDER | Design Firm: Venti caratteruzzi | Designer: Carlo Fiore
Client: Accademia Nazionale di Santa Cecilia

180 DAS RHEINGOLD | Design Firm: Gunter Rambow | Designer: Gunter Rambow
Client: Oper Frankfurt | Creative Team: Angelika Eschbach-Rambow

180 NORMA | Design Firm: Gunter Rambow | Designer: Gunter Rambow
Client: Oper Frankfurt | Creative Team: Angelika Eschbach-Rambow

180 DIE LUSTIGE WITWE (THE MERRY WIDOW) | Design Firm: Gunter Rambow
Designer: Gunter Rambow | Client: Oper Frankfurt | Creative Team: Angelika Eschbach-Rambow

181 L'AFRICAINE, VASCO DA GAMA | Design Firm: Gunter Rambow
Designer: Gunter Rambow | Client: Oper Frankfurt | Creative Team: Angelika Eschbach-Rambow

181 CAPRICCIO | Design Firm: Gunter Rambow | Designer: Gunter Rambow | Client: Frankfurt
Creative Team: Angelika Eschbach-Rambow

181 ENO AIDA | Design Firm: Rose | Designers: Rose, Toby Edwards, Ali Boschen
Client: English National Opera | Photographer: Jonathan Knowles
Creative Director: Simon Elliott | Copywriter: Andy Rigden

226 CREDITS & COMMENTARY

181 OGAKI MATSURI FESTIVAL | Design Firm: Tetsuro Minorikawa
Designer: Tetsuro Minorikawa | Client: Ogaki Matsuri Festival Poster Exhibition Committee

182 TOSCA | Design Firm: Carmit Design Studio | Designer: Carmit Haller
Client: Haller Metalwerks

182 WI-FI FREE ZONE | Design Firm: Leynivopnid | Designers: Unnur Valdis, Einar Gylfason
Client: Flothetta | Writer: Unnur Valdis | Photographer: Gunnar Svanberg
Main Contributor: Einar Gylfason | Art Director: Einar Gylfason

182 BEHIND THE AMUSEMENT PARK LAUNCH PARTY | Design Firm: Behind the Amusement Park | Designer: Johan Ressle, Helene Havro | Client: Self-initiated

183 DREAM BIG | Design Firm: McCandliss and Campbell
Designer: McCandliss and Campbell | Client: Self-initiated

183 MILTON GLASER SVA SUBWAY POSTERS | Design Firm: Visual Arts Press, Ltd.
Designer: Milton Glaser | Client: School of Visual Arts | Executive Creative Director: Anthony P. Rhodes | Creative Director: Gail Anderson

183 YOU CAN DO IT AT WOOSUK! | Design Firm: Woosuk University
Designer: Mi-Jung Lee | Client: Self-initiated

183 HOMING IN: TODD HIDO B-SIDES | Design Firm: Aufulish & Warinner
Designer: Bob Aufulish | Client: Editions Editions | Photographer: Todd Hido

184 MIYAJIMA HATSUMOUDE 2018 | Design Firm: imageon Co.,LTD.
Designer: Naoyuki Fukumoto | Client: Miyajima Tourist Association
Ad Agency: West Japan Marketing Communications, Inc.

184 THIS IS VIVID | Design Firm: Osborne Ross | Designers: Andrew Ross, Deborah Osborne
Client: Boss Print | Photographer: Tim Flach

184 POSTER SERIES | Design Firm: Oncetudio | Designer: Yaoyao Huang
Client: Jin San Yi Silk Store

184 YOMAR AUGUSTO VISITING DESIGNER POSTER | Design Firm: COLLINS
Designer: Sohee Kim | Client: Self-initiated | Chief Creative Officer: Matt Luckhurst

185 EDEL RODRIGUEZ SVA SUBWAY POSTERS | Design Firm: Visual Arts Press, Ltd.
Designers: Ryan Durinick, Edel Rodriguez, Visual Arts Press, Ltd. | Client: School of Visual Arts
Senior Designer: Ryan Durinick | Illustrator: Edel Rodriguez
Executive Creative Director: Anthony P. Rhodes | Creative Director: Gail Anderson

185 AGENCY MISSION INTERNAL COMMUNICATIONS | Design Firm: DiMassimo Goldstein
Designers: Claudia Mark, Matt Peters, Tom Christmann
Client: Self-initiated | Design Director: Claudia Mark | Senior Designer: Matt Peters
Chief Creative Officer: Tom Christmann

185 WANDA PROMOTION POSTER | Design Firm: Landor San Francisco
Designer: Thomas Hutchings | Client: Self-initiated

185 TYPOJANCHI 2017 - BODY & TYPOGRAPHY 01 | Design Firm: DAEKI & JUN studio
Designers: Daeki Shim, Hyojun Shim | Client: Korea Crafts & Design Foundation(KCDF) / Typojanchi 2017 | Typeface Designer: Ayoung Jung | Art Directors: Daeki Shim, Hyojun Shim

186 TYPOJANCHI 2017 - BODY & TYPOGRAPHY 02 | Design Firm: DAEKI & JUN studio
Designers: Daeki Shim, Hyojun Shim | Client: Korea Crafts & Design Foundation(KCDF) / Typojanchi 2017 | Typeface Designer: Ayoung Jung | Art Directors: Daeki Shim, Hyojun Shim

186 SAVE THE WHALES | Design Firm: NICE CREATIVE | Designer: Huang Yong
Client: cow design biennale

186 THAT CRAZY PERFECT SOMEDAY BOOK POSTER | Design Firm: Mazzarium Inc.
Designer: Mike Mazza | Client: Turtle Point Press | Author: Michael Mazza

186 FACES | Design Firm: Studio Geray Gencer | Designer: Geray Gencer
Client: Faculty of Fine Arts - Marmara University | Photographer: Ardan Ergüven

187 FACEOUT STUDIO POSTER | Design Firm: Faceout Studio | Designer: Lindy Martin
Client: Self-initiated | Illustrators: Circus Barker by Jerry Robinson (1941), Femme Fatale by Rudy Nappy (1951), Mark Twain by Joseph Keppler (1885), Biplane from Elson Basic Readers (1931)

187 WAVERLEY PARK | Design Firm: Hoyne | Designer: Nick Fels | Client: Mirvac

187 ESSENCE | Design Firm: IF Studio | Designers: Hisa Ide, Toshiaki Ide
Client: Brack Capital Real Estate | Stylist: Carin Sheve | Producer: Athena Azevedo
Photographer: Max Zambelli | Design Director: Hisa Ide
Creative Directors: Hisa Ide, Toshiaki Ide | Copywriter: Sarah Tan | Art Director: Kumiko Ide

187 TEXTURES | Design Firm: IF Studio | Designers: Hisa Ide, Toshiaki Ide
Client: Brack Capital Real Estate | Stylist: Carin Sheve | Producer: Athena Azevedo
Photographer: Max Zambelli | Design Director: Hisa Ide
Creative Directors: Hisa Ide, Toshiaki Ide | Copywriter: Sarah Tan | Art Director: Kumiko Ide

188 RETREAT | Design Firm: IF Studio | Designers: Hisa Ide, Toshiaki Ide | Client: Brack Capital Real Estate | Stylist: Carin Sheve | Producer: Athena Azevedo | Photographer: Max Zambelli
Design Director: Hisa Ide | Creative Directors: Hisa Ide, Toshiaki Ide | Copywriter: Sarah Tan
Art Director: Kumiko Ide

188 WORKSHOP | Design Firm: Hoyne | Designers: James Fitzgerald, Cindy Erlina, Pete Georgiou | Client: Milligan Group | Design Director: Peter Georgiou | Creative Director: Peter Drew

188 330 N WABASH POSTER SERIES | Design Firm: Pivot Design | Designers: Brett Tabolt, Kelsey Pawlowski, Britta Hernalsteen, Brock Haldeman | Client: Beacon Capital Partners, Cushman & Wakefield | Printers: Delicious Design League, Active

188 EAST VILLAGE'S GREATEST BUILDING | Design Firm: IF Studio
Designers: Hisa Ide, Toshiaki Ide | Client: Extell Development | Photographer: Julien Capmeil
Design Director: Hisa Ide | Creative Directors: Hisa Ide, Toshiaki Ide

189 UTOPIA | Design Firm: Kari Piippo Oy | Designer: Kari Piippo | Client: Goethe-Institut Israel

189 GROUND ZERO | Design Firm: Toyotsugu Itoh Design Office | Designer: Toyotsugu Itoh
Client: Chubu Creators Club

189 TOLERANCE | Design Firm: Dankook University | Designer: Hoon-Dong Chung
Client: Tolerance - a traveling poster project | Art Director: Hoon-Dong Chung

189 CLIMATE OF DENIAL | Design Firm: Justin Kemerling Design Co
Designer: Justin Kemerling | Client: America

190 ANOTHER WAR | Design Firm: Andrew Sloan | Designer: Andrew Sloan
Client: Self-initiated

190 EARTHQUAKE POSTER SUPPORT PROJECT | Design Firm: Yohei Takahashi
Designer: Yohei Takahashi | Client: Earthquake Poster Support Project, Tama Art University, Tokyo polytechnic University

190 WAR IS STUPID | Design Firm: Fons Hickmann m23 | Designer: Fons Hickmann
Client: Self-initiated

190 DECONSTRUCTING HATE | Design Firm: Ryan Russell Design | Designer: Ryan Russell
Client: H. Campbell and Eleanor R. Stuckeman School of Architecture and Landscape Architecture, The Pennsylvania State University

191 NANJING MASSACRE 1937 | Design Firm: Dalian RYCX Advertising Co., Ltd.
Designer: Yin Zhongjun | Client: Nanjing Graphic Designers Union Nanjing Museum

191 PATIENCE | Design Firm: Steiner Graphics | Designer: Rene V. Steiner
Client: Self-initiated

191 TOLERANCE | Design Firm: Braley Design | Designer: Michael Braley
Client: Anfachen Award

192 TOGETHERNESS | Design Firm: Braley Design | Designer: Michael Braley
Client: Third Open All-Russian Poster Competition

192 WAR OR PEACE | Design Firm: IF Studio & Magnus Gjoen
Designers: Hisa Ide, Toshiaki Ide | Client: Self-initiated | Producer: Sarah Tan
Creative Directors: Hisa Ide, Toshiaki Ide, Magnus Gjoen | Copywriters: Athena Azevedo, Toshiaki Ide | Artist: Magnus Gjoen | Art Director: Magnus Gjoen

192 FALLING SKIES | Design Firm: dnkstudio | Designer: Mykola Kovalenko | Client: 4th block

192 BASKETS (SEASON 3) | Design Firm: Ignition | Designer: FX Networks/Ignition
Client: FX Networks | Production: Lisa Lejeune (FX Networks) | Photographer: Matthias Clamer
Design Manager: Laura Handy (FX Networks) | Creative Directors: Todd Heughens, Ignition, Stephanie Gibbons, Michael Brittain | Senior Vice President, Print Design, FX Networks: Todd Heughens | President, Creative, Strategy & Digital, Multi-Platform Marketing, FX Networks: Stephanie Gibbons | Vice President, Print Design, FX Networks: Michael Brittain | Art Director: Sur Keath Moon (FX Networks)

193 SNOWFALL (SEASON 1) - SERIES | Design Firm: Iconisus | Designer: FX Networks/ Ignition | Client: FX Networks | Production: Lisa Lejeune (FX Networks) | Photographer: Matthias Clamer | Design Manager: Laura Handy (FX Networks) | Creative Directors: Todd Heughens, Stephanie Gibbons | Senior Vice President, Print Design, FX Networks: Todd Heughens
President, Creative, Strategy & Digital, Multi-Platform Marketing, FX Networks: Stephanie Gibbons | Art Director: Todd Russell | Director, Print Design, FX Networks: Todd Russell

193 ORGANISMO KAFKA | Design Firm: Marcos Minini | Designer: Marcos Minini
Client: Estúdio Delírio

193 NHO GRATIA | Design Firm: OGAWAYOUHEI DESIGN DESK | Designer: Youhei Ogawa
Client: DANCE WEST

193 LEMONS,LEMONS,LEMONS.LEMONS.LEMONS | Design Firm: H.Tuncay
Designer: Haluk Tuncay | Client: DOT Theatre

194 WOMEN (GRATË) | Design Firm: Eggra | Designer: Ngadhnjim Mehmeti
Client: The Albanian Theater Skopje | Photo Editor: Igor Nastevski

194 PLAN B | Design Firm: Atelier Bundi | Designer: Stephan Bundi
Client: Theater Biel Solothurn

194 THEATER BABEL ROTTERDAM | Design Firm: Studio Lonne Wennekendonk
Designer: Studio Lonne Wennekendonk | Client: Theater Babel Rotterdam

194 KING RICHARD III, THEATRE POSTER | Design Firm: Studio Cuculić
Designer: Vanja Cuculić | Client: City drama theatre Gavella

195 HAMLET | Design Firm: Carmit Design Stduio | Designer: Carmit Haller
Client: Haller Metalwerks

195 SUNDAY IN THE PARK WITH GEORGE | Design Firm: Dennard, Lacey & Associates
Designer: James Lacey | Client: Revival Theatre Company | Illustrator: James Lacey

195 NHO MARIE ANTOINETTE | Design Firm: OGAWAYOUHEI DESIGN DESK
Designer: Youhei Ogawa | Client: DANCE WEST

196 THE SOUND OF SILENCE | Design Firm: Meaghan A. Dee
Designer: Meaghan A. Dee | Client: Typo-poetry: Despite Black and White in Sound

197 LOVE OF TYPE | Design Firm: Landor San Francisco | Designer: Curt Rice
Client: Self-initiated

197 CAPE SANTA MARIA | BEACH RESORT | Design Firm: Stephen Guenther
Designer: Stephen Guenther | Client: Cape Santa Maria Beach Resort
Photographer: Stephen Guenther

197 TYPOGRAPHICS 2016 | Design Firm: Alex Seth
Designer: Alex Seth | Client: ArtCenter

197 CRUEL INTENTIONS: THE MUSICAL POSTER | Design Firm: The Pekoe Group
Designer: Briana Lynch | Client: Cruel Intentions Worldwide, LLC | Wardrobe: Tilly GrimesProject Coordinator: Richard Pham | Photographer: Jenny Anderson | Model: Lauren Zarkin
Creative Director: Christopher Lueck | Art Producer: Jason Murray

198 BROKEN LOVE | Design Firm: Carmit Design Studio | Designer: carmit haller
Client: Haller Metalwerks

198 EIGHT GRADUATED DESIGN PROGRAM TWENTY FIVE YEAR LATER
Design Firm: CARLOS PION NEW YOK | Designer: CARLOS PION
Client: ALTOS DE CHAVON SCHOOL OF DESIGN

198 THE AGONY OF CHOICE | Design Firm: Folkwang UdK
Designer: Thomas Kühnen & Phillip Berg | Client: Folkwang University of the Arts, Essen, NRW

198 LUCKY NUMBERS | Design Firm: hufax arts | Designer: Fa-Hsiang Hu
Client: ADLINK Technology Inc.

227 INDEX

DESIGN FIRMS

21xdesign ... 33	Eugene Lee ... 172	Leo Lin Design ... 172	Scott Laserow Posters ... 58
Alex Seth ... 197	Exit10 ... 171	Leynivopnid ... 182	Selman Design ... 168
Alt Group ... 65, 66	Faceout Studio ... 187	Libido inc. & Linda Graphica ... 171	Shawn Meek & Sixto Juan-Zavala ... 81
Andrew Sloan ... 190	Finn Nygaard ... 173	Magnus Gjoen ... 192	Sol Bi Doo ... 141
Angry Dog ... 91	FleishmanHillard ... 116	Marcos Minini ... 193	Sommese Design ... 70, 166
AN kiyoung Design Room ... 159	Folkwang UdK ... 198	Markham & Stein ... 157	Stavitsky Design ... 167
Ariane Spanier Design ... 94, 102	Fons Hickmann m23 ... 69, 98, 171, 190	Marlena Buczek Smith ... 129, 139	Steiner Graphics ... 191
ARSONAL ... 52, 57, 161-163	FX Networks ... 34, 35, 52, 53, 161, 192, 193	Martin French Studio ... 178	Stephen Guenther ... 197
Atelier Bundi AG ... 105, 131, 143, 145, 148, 156, 194	FX Networks/Bond/P+A/Ignition Iconisus ... 34	MAT ... 82, 172	Stout SF ... 46, 47, 152
Aufuldish & Warinner ... 158, 183	Graphic Art Seminar Laboratory ... 48, 51, 159	Mazzarium Inc. ... 186	Studio Cuculić ... 194
BANKOVPOSTERS ... 175	Gravdahl Design ... 42, 127	McCandliss and Campbell ... 183	Studio'farrell ... 132
Begum Gucuk ... 130	Gonca Koyuncu ... 168	Meaghan A. Dee ... 196	Studio Geray Gencer ... 186
Behind the Amusement Park ... 113, 182	Gunter Rambow ... 30, 71, 72, 103, 104, 106, 180, 181	Melchior Imboden ... 78, 97	STUDIO INTERNATIONAL ... 126
Bond ... 34, 35	HBO Latin America ... 162	Michael Schwab Studio ... 165	studioKALEIDO ... 168
Braley Design ... 60, 92, 99, 114, 138, 164-166, 191, 192	Henning Kreitel ... 177	Molly Tuttle Design ... 178	studio lindhorst-emme ... 96, 170
CARLOS PION NEW YORK ... 198	Hoyne ... 118, 119, 120, 121, 124, 187, 188	Monroe Creative Studio ... 85, 86, 156, 179	Studio Lonne Wennekendonk ... 89, 194
Carmit Design Studio ... 117, 150, 182, 198	hofmann.to ... 27	Namseoul University ... 115	Superunion ... 164
Carter Hales Design Lab Inc. ... 83, 84, 175	H. Tuncay Design ... 142, 144, 193	NICE CREATIVE ... 186	SVIDesign ... 40, 178
Center for Design Research ... 68	hufax arts ... 198	Norikyuki Kasai ... 170	Takashi Akiyama Studio ... 29, 50, 63, 76, 159
Charit Art Co., Ltd. ... 176	hufax arts Co., Ltd./ CUTe ... 28, 153	Number8 Creative Inc. ... 137	Ted Wright Illustration & Design ... 162, 167, 177
Cold Open ... 56, 160, 161, 163	Husmee ... 41, 88	OGAWAYOUHEI DESIGN DESK ... 193, 195	Tetsuro Minorikawa ... 181
COLLINS ... 31, 184	HYUK-JUNE JANG ... 39	Oncetudio ... 184	THERE IS Studio ... 100, 101
DAEKI & JUN Studio ... 64, 109, 185, 186	Iconisus ... 34, 193	Oregon State University ... 133	TOKY Branding + Design ... 62, 151, 169
Daisuke Kashiwa ... 164, 171	IF Studio ... 122, 123, 187, 188, 192	Osborne Ross ... 184	Tomaso Marcolla ... 134
Dalian RYCX Advertising Co., Ltd. ... 165, 191	Ignition ... 34, 192	OUWN ... 157	Toyotsugu Itoh Design Office ... 189
Dankook University ... 80, 189	imageon Co., LTD. ... 165, 184	Owen Gildersleeve Ltd. ... 179	Traction Factory ... 32
David Torrents ... 170	InSync PLUS ... 53-55	The Pekoe Group ... 146, 197	TracyLocke ... 156
Dennard, Lacey & Associates ... 195	Jeremy Honea ... 49	Penrose 300 ... 166	Tsushima Design ... 73, 136
Design SubTerra ... 168, 179	Jie-Fei Design ... 173	Pentagram ... 61, 128, 169	Underline Studio ... 43, 44
Dilara Sebnem Esendemir ... 173	João Machado Design ... 77, 87, 95, 110, 158, 173, 174, 177	Petrol Advertising ... 160, 163	Venti caratteruzzi ... 179, 180
DiMassimo Goldstein ... 185	Justin Kemerling Design Co ... 189	Pirtle Design ... 75	Ventress Design Works ... 90
Dizaino Studija Baklazanas ... 156	Kari Piippo Oy ... 45, 157, 189	Pivot Design ... 188	VEX Robotics in-house studio ... 159
Dnkstudio ... 125, 192	Kaveh Haerian ... 178	Purdue University ... 159	Visual Arts Press, Ltd. ... 107, 108, 172, 183, 185
Doğan Arslan ... 174	LaMachina Design Co. ... 176	Randy Clark ... 74, 79, 172	Warkulwiz Design Associates ... 157
Eggra ... 194	Landor San Francisco ... 185, 197	Red Square ... 111	Wesam Mazhar Haddad ... 140
Elephant In The Room ... 176	Langrand ... 147, 149	Rikke Hansen ... 26, 135, 164	Woosuk University ... 170, 183
Elsenbach Design ... 93		Rose ... 181	Yinsen ... 67
Emerson, Wajdowicz Studios ... 169		Ryan Russell Design ... 190	Yohei Takahashi ... 190
Estudio Pep Carrió ... 59, 112, 158, 175		Sandstrom Partners ... 174	Zulu Alpha Kilo ... 38, 158
		Savannah College of Art and Design ... 174, 175	

CLIENTS

4th block ... 192	BMW ... 39	Extell Development ... 188	Japanese Academy of Facial Studies ... 165
20th Century Fox ... 54	Boss Print ... 184	Facebook ... 46, 47	Japan Graphic Designers Association Hiroshima ... 136
60th Anniversary Helvetica Typeface ... 41	Brack Capital Real Estate ... 122, 123, 187, 188	Faculty of Fine Arts - Marmara University ... 186	Jazz Kicks Band ... 179
2018 PyeongChang Olympic ... 141	Bravo ... 161	Flothetta ... 182	Jazz W Ruinach ... 174
AAF Cedar Rapids / Iowa City ... 92	Cache Valley Gardener's Market Association ... 168	Focus Features ... 162, 163	Jay Own ... 38
Accademia Nazionale di Santa Cecilia ... 179	California College of the Arts ... 158	Folkwang University of the Arts, Essen, NRW ... 198	Jin San Yi Silk Store ... 184
Activision ... 160, 163	Cape Santa Maria Beach Resort ... 197	Fragrance Group ... 119, 120	The Johnny Cash Museum/Nashville ... 162
ADLINK Technology Inc. ... 198	The Catastrophic Theatre ... 147, 149	FX Networks ... 34, 35, 52, 53, 161, 192, 193	Kabak&Lin ... 179
AIGA Philadelphia ... 166	Center of Russian Avant-garde ... 156	Gaudeamus Muziekweek ... 89	KINDAI University ... 51, 159
AIGA Philly 35th Anniversary ... 157	Changfa ... 121	Geberit ... 156	KINDAI University (Department of Arts) ... 48
The Albanian Theater Skopje ... 194	Chicago Latino Film Festival ... 176	Global Citizen ... 169	Korea Crafts & Design Foundation(KCDF) / Typojanchi 2017 ... 109, 185, 186
ALS Association Wisconsin Chapter ... 32	China University of Technology ... 28	GlobalMusicDrama LTD ... 146	Korea National University of Arts ... 73
Altos De Chavon School of Design ... 198	Chubu Creators Club ... 189	GMK Graphic Designers Association Turkey ... 173	Kunsthalle zu Kiel ... 94
America ... 189	City drama theatre Gavella ... 194	Goethe-Institut Israel ... 189	The language of war and peace in the new media ... 80
Anfachen Award ... 191	Clube Criativos de Portugal ... 173	Golden Bee Moscow ... 72, 125, 131	Lucy's Fried Chicken ... 61
Another Planet Entertainment ... 100, 101, 179	COCS GmbH - Congress Organisation C. Schäfer and Prof. Dr. Horst Neuhaus ... 93	Haller Metalwerks ... 117, 150, 182, 195, 198	LUMINE CO.,LTD. ... 157
Architektur Forum Bern ... 156	cow design biennale ... 186	Harley-Davidson Canada ... 38	MACNA - Museu de Arte Contemporânea Nadir Afonso ... 77
Ardel ... 176	Creative Process/St. Louis Fashion Fund ... 151	H. Campbell and Eleanor R. Stuckeman School of Architecture and Landscape Architecture The Pennsylvania State University ... 190	Made Property Group ... 118
Armando Milani ... 75, 82	Cruel Intentions Worldwide, LLC ... 197	Heiwa Paper Co., Ltd / Paper Voice ... 171	Madrid Grafica ... 114
Art at the University of Alabama at Birmingham ... 173	CSX Transportation, John Kitchens, CSX ... 171	HfG Karlsruhe ... 71	Mangart Committee ... 63
ArtCenter ... 197	Dallas Society of Visual Communications ... 49	Houser, Brian ... 162	Manifold ... 168
Artes Gráficas Palermo ... 112	DANCE WEST ... 193, 195	Hulu ... 57, 160	Marc Martí ... 170
Asgard Brewing Company ... 90	Das Renn Treffen ... 157	Husmee Studio Graphique! ... 158	Metropolitan State University of Denver ... 81
Asia Network Beyond Design ... 74, 79, 172	DESIGN TO UNITE ... 132	Hyundai Card Design Library / Korea Craft & Design Foundation(KCDF) / Typojanchi ... 64	Musikalische Akademie Mannheim ... 102
Auckland Council ... 65, 66	DIMAD/Ayuntamiento de Madrid ... 59	Invitational poster exhibition ... 97	MIEF company ... 175
Audi of America ... 156	DOT Theatre ... 142, 144, 193	Invited AGI Poster Exhibition ... 78	Milligan Group ... 188
Austal USA ... 111	The Dumbo Improvement District ... 168	ISHR International Society for Human Rights ... 115	Ministry of Culture, Sports and Tourism ... 170
Bard on the Beach ... 175	Earthquake Poster Support Project, Tama Art University, Tokyo polytechnic University ... 190	ITC - Technology Center ... 67	Mirvac ... 187
Beacon Capital Partners, Cushman & Wakefield ... 188	The East Cut Community Board District ... 31	Ivancic i sinovi ... 40	Miyajima Tourist Association ... 184
Beykoz Kundura ... 85, 86	Editions Editions ... 183	JAGDA Hokkaido ... 170	Mulligan, Dave ... 178
BICeBé ... 164	English National Opera ... 181		The Museum of Modern Art ... 172
BICeBé and National Museum of Art, La Paz ... 26	Estúdio Delírio ... 193		Nakanokuchi memorial hall one's predecessor ... 76
Biennal del Cartel Bolivia BICeBé ... 42			Naked ... 178
The Biennial of Poster Bolivia BICeBé ... 45, 164			Nanjing Graphic Designers Union Nanjing Museum ... 191

INDEX

Nascente Cooperativa de Acção Cultural, CRL ... 87, 174
Neubad Luzern ... 69, 98
Neustahl GmbH ... 27
Nickelodeon ... 56
Nihonbashi Mitsukoshi ... 167
Nippon Beverages ... 91
Northwest Film Center ... 174
Ogaki Matsuri Festival Competition ... 60
Ogaki Matsuri Festival Poster Exhibition Committee ... 181
Ogaki Poster Museum ... 95
Oper Frankfurt ... 30, 103, 104, 106, 180, 181
Pando Populus ... 164-166
Pecha Kucha Austin ... 169
Pendelton ... 162, 167
Pennsylvania Festival of the Arts ... 70, 166
Poland Auschwitz international political Poster Biennale ... 165
Posterbiennal Mexico ... 171
Poster for Tomorrow ... 134
Posters for Peace ... 127
Purdue Contemporary Dance Company ... 159
Revival Theatre Company ... 195
RiverRun International Film Festival ... 176, 177
R. - Raum für drastische Maßnahmen ... 170
Russia Designers Association (RDA) ... 167
San Sebastian International Film Festival ... 88
School of Clay Arts ... 168
School of Visual Arts ... 107, 108, 183, 185
Segunda Llamada ... 58
Self-initiated ... 33, 43, 44, 62, 68, 110, 116, 126, 129, 130, 133, 137, 139, 140, 152, 158, 162, 169, 174, 175, 178, 182-185, 187, 190, 191, 192, 197
Shaddox, Billy ... 178
Shasta Ventures ... 165
Singapore Parks ... 164
Speak UP ... 135
St. Paul & The Broken Bones ... 99
Strelka Design Biennale competition ... 173
Superfly ... 179
TAK ... 113
Tama Art University ... 29
Tama Art University Illustration Studies ... 50, 171
Tama Art University Dessin Project ... 159
Taiwan Poster Design Association ... 172
Techin ... 124
Theater Biel Solothurn ... 194
Theater Orchester Biel Solothurn ... 105, 143, 145, 148
Third Open All-Russian Poster Competition ... 138, 192
Tolerance - a traveling poster project ... 189
TPDA ... 153
Turtle Point Press ... 186
Typo-poetry: Despite Black and White in Sound ... 196
UCCI Unión de Ciudades Capitales Iberoamericanas ... 175
Universidad Autónoma Metropolitana ... 157, 158
Vancouver Writers Fest ... 83, 84
Vesa Mikkola ... 38
VEX Robotics, Inc. ... 159
Walt Disney Studios Motion Pictures ... 55
Weserburg Museum for modern Art, Bremen and University of the Arts, Bremen ... 96
Westend Fotoschule, Bremen ... 172
"We the People" project ... 128
Williams Sonoma - California ... 177
WTMD Radio ... 178
YouTube Red ... 161, 163
Zentral- und Landesbibliothek Berlin ... 177

DESIGNERS

Aitken, Ruby ... 124
Akiyama, Takashi ... 29, 50, 63, 76, 159
Akyuz, Emirhan ... 156
AN, kiyoung ... 48, 51, 159
Arslan, Doğan ... 174
ARSONAL ... 52, 57, 161-163
Aufuldish, Bob ... 158, 183
Bagley, Caroline ... 31
Bankov, Peter ... 175
Becker, Stephie ... 102
Beeson, Emilee ... 171
Bell, Peter ... 32
Berg, Phillip ... 198
Bileva, Divna ... 174, 175
Bissland, R.P. ... 168, 179
Boschen, Ali ... 181
Bosse, Ryan ... 152
Braley, Michael ... 60, 92, 99, 114, 138, 164, 165, 166, 191, 192
Buczek Smith, Marlena ... 129, 139
Bundi, Stephan ... 105, 131, 143, 145, 148, 156, 194
Buzelli, Chris ... 107, 108
Campbell, Nancy ... 183
Carmit Design Studio ... 117
Carrió, Pep ... 59, 158, 175, 112
Carter, Sean ... 83, 84
Cehovin, Eduard ... 68
Chung, Hoon-Dong ... 80, 189
Christmann, Tom ... 185
Clark, Randy ... 74, 79, 172
Cold Open ... 56, 160, 161, 163
Cordts, Maddie ... 159
Cronin, Markham ... 157
Cuculić, Vanja ... 194
Cullen, Jordan ... 152
Dee, Meaghan A. ... 196
Delaney, Brian ... 159
Doo, Sol Bi ... 141
Durinick, Ryan ... 185
Edwards, Toby ... 181
Elsenbach, Nicole ... 93
Erlina, Cindy ... 188
Esendemir, Dilara Şebnem ... 173
Farrell, Tom ... 132
Fels, Nick ... 119, 120, 124, 187
Fernandes, Rafael ... 91
Fiore, Carlo ... 179, 180
Fitzgerald, James ... 118, 121, 188
Forister, Kevin ... 156
Franzino, Anthony ... 156
French, Martin ... 178
Fry, Barrett ... 61
Fukumoto, Naoyuki ... 165, 184
FX Networks ... 34, 35, 52, 53, 161, 192, 193
FX Networks/Bond ... 35
FX Networks/Ignition ... 192, 193
FX Networks/Bond/P+A/Ignition Iconisus ... 34
Gencer, Geray ... 186
Georgiou, Peter ... 118, 121, 188
Gildersleeve, Owen ... 179
Glaser, Milton ... 183
Gopaul, Rosie ... 83, 84
Goryacheva, Irina ... 156
Granado, Selena ... 159
Gravdahl, John ... 42, 127
Gucuk, Begum ... 130
Guenther, Stephen ... 197
Gutierrez, Christine ... 159
Gylfason, Einar ... 182
Hackley, Will ... 176
Haddad, Wesam Mazhar ... 140
Haerian, Kaveh ... 178
Haldeman, Brock ... 188
Haller, Carmit ... 150, 182, 195, 198
Hansen, Rikke ... 26, 135, 164
Havro, Helene ... 113, 182
HBO Latin America ... 162
Hernalsteen, Britta ... 188
Hickmann, Fons ... 69, 98, 171, 190
Hofmann, Matthias ... 27
Holohan, Kelly ... 166
Honea, Jeremy ... 49
Hu, Fa-Hsiang ... 28, 153, 198
Huang, Yaoyao ... 184
Husmee ... 41, 88
Hutchings, Thomas ... 185
Ide, Hisa ... 122, 123, 187, 188, 192
Ide, Toshiaki ... 122, 123, 187, 188, 192
Imboden, Melchior ... 78, 97
InSync PLUS / FX Networks ... 53
ISHIGURO, ATSUSHI ... 157
Itoh, Toyotsugu ... 189
JANG, HYUK-JUNE ... 39
Jang, Sherry ... 83, 84, 175
Juan-Zavala, Sixto ... 81
Kabalka, Jordan ... 111
Karapinar, Dogukan ... 85, 86
Kasai, Norikyuki ... 170
Kashiwa, Daisuke ... 164, 171
Kemerling, Justin ... 189
Kennedy-Darling, Molly ... 174
Kepple, Paul ... 166
Kidd, Nick ... 156
Kim, Sohee ... 184
Kizildelioglu, Emre ... 179
Kovalenko, Mykola ... 125, 192
Koyuncu, M. Gonca ... 168
Kreitel, Henning ... 177
Kühnen, Thomas ... 198
Lacey, James ... 195
Lam, Julie ... 33
Lambert, Scott ... 164
Laserow, Scott ... 58
Lee, Eugene ... 172
Lee, Mi-Jung ... 170, 183
Lin, Leo ... 172
Lindhorst-Emme, Sven ... 96, 170
Ljubicic, Boris ... 126
Lynch, Briana ... 146, 197
MacCormack, Dermot ... 33
Machado, João ... 77, 87, 95, 110, 158, 173, 174, 177
Magana, Elizabeth ... 159
Marcolla, Tomaso ... 134
Mark, Claudia ... 185
Martin, Lindy ... 187
Martinez, Antonio ... 159
Mazza, Mike ... 186
McCandliss, Trevett ... 183
McCarn, Jennifer ... 174
McElroy, Patricia ... 33
Meek, Shawn ... 81
Mehmeti, Ngadhnjim ... 194
Meis, Ryan ... 46, 47
Mendez, Manny ... 169
Minini, Marcos ... 193
Minorikawa, Tetsuro ... 181
Muthucumaru, Kishan ... 54, 55
Nygaard, Finn ... 173
Oguma, Chikako ... 167
Ogawa, Youhei ... 193, 195
Osborne, Deborah ... 184
Palmer, Chelsea ... 175
Park, Yonghoon ... 64
Pawlowski, Kelsey ... 188
Peña, Fidel ... 43, 44
Peters, Matt ... 185
Petrol Advertising ... 160, 163
Piippo, Kari ... 45, 157, 189
PION, CARLOS ... 198
Pirtle, Lucas ... 75
Pirtle, Woody ... 75
Polansky, Deklah ... 132
Pomareda, Jorge ... 176
Poole, Dean ... 65, 66
Pradera, María ... 67
Preas, Magan ... 159
Pusiri, Charit ... 176
Rambow, Gunter ... 30, 71, 72, 103, 104, 106, 180, 181
Ressle, Johan ... 113, 182
Rice, Curt ... 197
Ritoh, Linda ... 171
Rodriguez, Edel ... 185
Rose ... 181
Ross, Andrew ... 184
Rottke, Helmut ... 93
Russell, Ryan ... 190
Sato, Kei ... 137
Sayavera, Lorena ... 67
Schwab, Michael ... 165
Selman Design ... 168
Seth, Alex ... 197
Schick, Andrew ... 83, 84
Shim, Daeki ... 64, 109, 185, 186
Shim, Hyojun ... 109, 185, 186
Shin, Jun Bum ... 133
Sigman, David L. ... 159
Sloan, Andrew ... 190
Smith, Buck ... 116
Sommese, Lanny ... 70, 166
Soto, Greg ... 55
Spanier, Ariane ... 94, 102
Stamper, Ashford ... 62
Stavitsky, Vitaly ... 167
Steiner, Rene V. ... 191
Stone, Benjamin ... 83, 84
Strickland, Spencer ... 147, 149
Striebel, Justin ... 169
Studio Lonne Wennekendonk ... 89, 194
Sun, Byoung-il ... 115
Tabolt, Brett ... 188
Takahashi, Yohei ... 190
Taylor, Haley ... 169
Tenorio, Sandra ... 158
THERE IS Studio ... 100, 101
Torrents, David ... 170
Towell, Kelcey ... 151
Tsushima, Hajime ... 73, 136
Tuncay, Haluk ... 142, 144, 193
Türkmen, Mehmet Ali ... 82, 172
Tuttle, Molly ... 178
Vaage, Erik Berger ... 31
Valdis, Unnur ... 182
Ventress, Tom ... 90
Ventura, Rachel ... 171
Vidakovic, Sasha ... 40, 178
Virak, Kennady ... 65, 66
Visual Arts Press, Ltd. ... 185
Wajdowicz, Jurek ... 169
Warkulwiz, Bob ... 157
Widlic, Christian ... 31
Windhagen, Wiebke ... 93
Wolverton, Jeffrey ... 128
Wright, Ted ... 162, 167, 177
Wu, Winnie ... 168
Yang, Jie-Fei ... 173
Yong, Huang ... 186
Yu, Tony ... 83, 84
Zhongjun, Yin ... 165, 191
Zulu Alpha Kilo ... 38, 158

INDEX

CREATIVE DIRECTORS/ASSOCIATE CREATIVE DIRECTORS/EXECUTIVE CREATIVE DIRECTORS

Anderson, Gail 107, 108, 183, 185	Fenn, Noel ... 38	InSync PLUS ... 53	Reinmuth, Steve 31
ARSONAL 52, 57, 161, 162, 163	Gibbons, Stephanie 35, 52, 53,	Ishiguro, Atsushi 157	Rhodes, Anthony P. ... 107, 108, 183, 185
Bell, Peter ... 32	.. 161, 192, 193	Krekeler, Sherri 156	Smith, Larry 179
Bond ... 35	Gjoen, Magnus 192	La Ferla, Marcello (Bravo) 161	Sugiuchi, Scott 171
Brittain, Michael 161, 192	Gokalp, Onur 85, 86, 156, 179	Lueck, Christopher 146, 197	Thoelke, Eric 62, 151, 169
Caie, Andrew 38	Green, Blair (Focus Features) . 162, 163	Muthucumaru, Kishan 55	Tsushima, Yukiko 136
Dawson, Claire 43, 44	Heughens, Todd 34, 35, 52, 53,	Oke, Allen .. 38	Vidakovic, Sasha 40, 178
Day, Glen ... 156	.. 161, 192, 193	P+A .. 34	Wadley, Jeff ... 54
Drew, Peter .. 188	Ide, Hisa 122, 123, 187, 188, 192	Peña, Fidel 43, 44	
Elliott, Simon 181	Ide, Toshiaki ... 122, 123, 187, 188, 192	Poole, Dean 65, 66	
Ellis, Dan ... 164	Ignition ... 192	Redding, Ray 147, 149	

ART DIRECTORS

Akyuz, Emirhan 179	Gylfason, Einar 182	McMullen, Brendan 158	Shim, Daeki 64, 109, 185, 186
ARSONAL 52, 57, 161-163	Hatten, Greg 167	Moon, Keath 52, 161, 192	Shim, Hyojun 109, 185, 186
Beeson, Emilee 171	Ide, Kumiko 122, 123, 187, 188	Phuong, Lisa 38	Stout, DJ 61, 128, 169
Brittain, Michael 34, 35	InSync PLUS 53	Prisco, Melanie 174	Wajdowicz, Jurek 169
Chung, Hoon-Dong 80, 189	Janney, Dawn 177	Ritoh, Linda 171	Wilson, Rob (FX Networks) 34, 35
D'Elia, Paul V. 161	McCarn, Jennifer 175	Russell, Todd (FX Networks) .. 53, 161, 193	
Gjoen, Magnus 192	McElroy, Patricia 33	Sato, Kei .. 137	

DESIGN DIRECTORS

Georgiou, Peter 188	Ide, Hisa 122, 123	Lambert, Scott 164	Nguyen, David Minh 31
	... 187, 188	Mark, Claudia 185	Ohia, Tyrone 65, 66

PHOTOGRAPHERS

Anderson, Jenny 197	Fernández, Antonio 59, 112, 158, 175	Kepple, Paul 166	Shimizu, Takeshi 136
ARSONAL ... 52	Flach, Tim ... 184	Knowles, Jonathan 181	Sigman, David L. 159
Becker, Michael 161	Folger, Claire 162	Mori, Yoshiyuki (series 6/7, 7/7) 171	Svanberg, Gunnar 182
Capmeil, Julien 188	Greenberg, Jill 57	Moriyama, Tomohiko (series 4/7, 5/7) ... 171	Tanyeli, Serdar 142, 144
Clamer, Matthias 161, 192, 193	Guenther, Stephen 197	Ockenfels, Frank 34, 35	Tseytlin, Olesa 167
English, Jack 163	Hido, Todd .. 183	Okano, Toaki 65, 66	Weeks, Paul 43, 44
Ergüven, Ardan 186	Holohan, Kelly 166	Okuwaki, Koichi (series 2/7, 3/7) ... 171	Zambelli, Max 122, 123, 187, 188

WRITERS/COPYWRITERS

ARSONAL 162, 163	Mallery, Coleman 38	Sanders, Jay 32	Tsushima, Yukiko 73
Azevedo, Athena 192	Pacey, Jacob 158	Sopocy, Paul 57	Valdis, Unnur 182
Cassard, Reese 171	Ricci, Frank 174, 175	Tan, Sarah 122, 123,	
Ide, Toshiaki 192	Rigden, Andy 181	... 187, 188	

ILLUSTRATORS

Always With Honor 174	ICHIJYO, HIKARU 157	Nappy, Rudy 187	Vidakovic, Sasha 40
ARSONAL 52, 161	Jang, Sherry 83, 84	Robinson, Jerry 187	Vital, Jesse .. 161
Buzelli, Chris 107, 108	Kellum, Alaska S. 171	Rodriguez, Edel 185	Warinner, Kathy 158
Elsaadi, Nabil 38	Keppler, Joseph 187	Schick, Andrew 83, 84	Wright, Ted 162
Elson Basic Readers 187	Lacey, James 195	Stone, Benjamin 83, 84	Yu, Tony ... 83, 84
Gopaul, Rosie 83, 84	Lam, Julie .. 33	Ventress, Tom 90	

I first got to know Graphis as a student, when it was still a Swiss design magazine. Even then, Graphis was already known for representing the best graphic design in the world. I was always very impressed with the quality of the entries.

Fons Hickmann, *Founder, Fons Hickmann m23*

230 WINNERS DIRECTORY

PLATINUM

21xdesign
www.21xdesign.com
2713 S. Kent Road
Broomall, PA 19008
United States
Tel +1 610 325 5422
info@21xdesign.com

COLLINS
www.wearecollins.com
747 Clementina St.
San Francisco, CA 94103
United States
Tel +1 203 570 2697
joanna@wearecollins.com

FX Networks/Bond/P+A/Ignition/Iconisus
www.fxnetworks.com
10201 W. Pico Blvd., Bldg. 103, Rm. 3549
Los Angeles, CA 90064
United States
Tel +1 310 369 5983
sarit.snyder@fxnetworks.com

Gunter Rambow
www.gunter-rambow.com
Domplatz 16
D-18273 Guestrow
Germany
GunterRambow@web.de

Hofmann.to
www.hofmann.to
Weggisgasse 1
Luzern LU 6003
Switzerland
Tel +41 (0)41 210 55 45
matthias@hofmann.to

hufax arts Co., Ltd./ CUTe
www.facebook.com/HufaxArts
13F., No.17, Ln. 47, Sec. 1,
Baofu Road, Yonghe Dist.
New Taipei City 23444
Taiwan
Tel +8862 25030158
(or +886 933 991 520)
hufa@ms12.hinet.net

Rikke Hansen
www.wheelsandwaves.dk
Klovtoftvej 32
Roedding 6630
Denmark
+45 233 13 560
rh@wheelsandwaves.dk

Takashi Akiyama Studio
3-14-35 Shimo-Ochiai
Shinjuku-ku, Tokyo 161-0033
Japan
Tel +81 3 3565 4316
akiyama@t3.rim.or.jp

Traction Factory
www.tractionfactory.com
247 S. Water St.
Milwaukee, WI 53204
United States
Tel +1 414 944 0900
tf_awards@tractionfactory.com

GOLD

Alt Group
www.altgroup.net
16 Mackelvie St.
Grey Lynn, Auckland 1021
New Zealand
Tel +64 9 3604785
luke@altgroup.net

Angry Dog
www.angrydog.com.br
Rua. Dias de Toledo, 64 - 48 - Saúde
São Paulo - SP, 04143-030
Brazil
rafael@angrydog.com.br

Ariane Spanier Design
www.arianespanier.com
Oranienstr. 22
Berlin, Berlin 10999
Germany
Tel +49 30 44033923
mail@arianespanier.com

ARSONAL
www.arsonal.com
3524 Hayden Ave.
Culver City, CA 90232
United States
Tel +1 310 815 8824
info@arsonal.com

Atelier Bundi AG
www.atelierbundi.ch
Schlossstrasse 78
Boll Berne CH-3067
Switzerland
Tel +41 31 981 00 55
bundi@atelierbundi.ch

Begum Gucuk
www.begumgucuk.com
Istanbul 34718
Turkey
+90 535 022 3404
drbegumgucuk@gmail.com

Behind the Amusement Park
www.behindtheamusementpark.com
Långa gatan 12
Stockholm, Stockholm 11521
Sweden
Tel +46 733 311 009
helene@b-t-a-p.com

Braley Design
www.braleydesign.com
3469 Lannette Lane
Lexington, KY 40503
United States
Tel +1 415 706 2700
braley@braleydesign.com

Carmit Design Studio
www.carmithaller.com
2208 Bettina Ave.
Belmont, CA 94002
United States
Tel +1 650 283 1308
carmit@carmitdesign.com

Carter Hales Design Lab Inc.
www.carterhales.com
377 W. Sixth Avenue
Vancouver, BC V5Y 1L1
Canada
Tel +1 604 630 5566
lab@carterhales.com

Center for Design Research
www.cehovin.com
Ulica Milana Majcna 35
Ljubljana SI-1000
Slovenia
Tel +386 40 458 657
eduard.cehovin@siol.net

Cold Open
www.coldopen.com
1313 Innes Pl.
Venice, CA 90291
United States
Tel +1 310 399 3307
reception@coldopen.com

DAEKI & JUN Studio
www.daekiandjun.com
3F, DAEKI & JUN
Seoul
South Korea
Tel +82 (0) 10 3104 0831
win.daekiandjun@gmail.com

Dankook University
Room 317, College of Arts, Dankook
University, 126, Jukjeon, Suji
Yongin Gyeonggi 448-701
South Korea
+82 31 8005 3106
finvox3@naver.com

Dnkstudio
www.dnkstudio.com.ua
Pri Sajbach 32
Bratislava 83106
Slovakia
design@dnkstudio.com.ua

Elsenbach Design
Südstraße 12
Hückeswagen, NRW 42499
Germany
Tel +49 (0)2192 9367948
Mail@elsenbach-Design.de

Estudio Pep Carrió
www.pepcarrio.com
C/ Génova, 11, 7°D
Madrid, Madrid 28004
Spain
Tel +34 913 080 668
info@pepcarrio.com

FleishmanHillard
200 N. Broadway
St. Louis, MO 63102
United States
Tel +1 314 982 8781
pam.thomas@fleishman.com

Fons Hickmann m23
www.m23.de
Mariannenplatz 23
Berlin, Berlin 10997
Germany
Tel +49 3069518501
fons@m23.de

Graphic Art seminar laboratory
www.facebook.com/ANkiyoung
KINDAI University(E-campus, A-2F),
Sinkamikosaka 228-3
Higashi-osaka Osaka 577-0813
Japan
Tel +81 90 9319 9396
aky6815@hotmail.com

Gravdahl Design
www.gravdahldesign.com
PO Box 729
Fort Collins, CO 80524
United States
Tel +1 970 482 8807
john@propeller-press.com
john@gravdahldesign.com

Gunter Rambow
www.gunter-rambow.com
Domplatz 16 D-18273 Guestrow
Germany
GunterRambow@web.de

H. Tuncay Design
www.haluktuncay.com
Omer Rustu Pasa Sokak
Birlik Apt. 26/8 Besiktas Istanbul
Turkey
Tel +90 532 588 3747
haltuncay@gmail.com

Hoyne
www.hoyne.com.au
Level 5 99 Elizabeth St.
Sydney NSW 2000
Australia
Tel +61 419 290 768
andrew@hoyne.com.au

hufax arts Co., Ltd./ CUTe
www.facebook.com/HufaxArts
13F., No.17, Ln. 47, Sec. 1, Baofu
Road, Yonghe Dist.,
New Taipei City 23444
Taiwan
Tel +886 2 25030158
 +886 933 991 520)
hufa@ms12.hinet.net

Husmee
www.husmee.com
c/ Melodi 5 Bajo
San Sebastián, Guipuzcoa 20009
Spain
Tel +34 943 22 56 57
alain@husmee.com

HYUK-JUNE JANG
www.edubank.hansung.ac.kr
Samseongyo-ro 16-gil
Hansung University Design & Art
Institute, Visual Communication Design
Seoul, Seongbuk-gu 02876
South Korea
+82 (0)10 2618 4298
wkdgurwns21@naver.com

IF Studio
www.ifstudiony.com
34 W. 27th St.
New York, NY 10001
United States
Tel +1 203 550 1432
toshi@ifstudiony.com

InSync PLUS
www.insync.plus
3530 Wilshire Blvd., Suite 1500
Los Angeles, CA 90010
United States
Tel +1 323 965 4800
candiv@insync.plus

Jeremy Honea
sweetashoney.com
7557 Rambler Road
Dallas, TX 75231
United States
jeremy.honea@gmail.com

João Machado Design
www.joaomachado.com
Rua Padre Xavier Coutinho, 125
Porto 4150-751
Portugal
Tel +351 226103772
geral@joaomachado.com

Kari Piippo Oy
www.piippo.com/kari
Katajamäenkatu 14
Mikkeli 50170
Finland
Tel +358 15 162187
kari@piippo.com

KINDAI university
www.facebook.com/ANkiyoung
KINDAI University(E-campus,A-2F),
Sinkamikosaka 228-3,
Higashi-osaka Osaka 577-0813
Japan
Tel +81 90 9319 9396
aky6815@hotmail.com

Langrand
www.langrandco.com
5120 Woodway Drive, Suite 7029
Houston, TX 77056
United States
Tel +1 713 225 5900
nancy@langrandco.com

Marlena Buczek Smith
www.marlenabuczek.com
United States
marlenabuczeksmith@gmail.com

MAT
www.matistanbul.net
Cihangir Caddesi
38/3, Cihangir
Beyoğlu, Istanbul 34433
Turkey
Tel +90 532 292 38 57
mat@matistanbul.net

Melchior Imboden
Eggertsbühl
CH-6374 Buochs
Switzerland
j@2xgoldstein.de

Monroe Creative Studio
Kuloğlu Mh. Güllabici Sk. Venti Ap.
No: 20/2 Cihangir
Beyoglu
Turkey
info@monroeistanbul.com

Namseoul University
Cheonansi, Chungnam 31020
South Korea
sunbi155@naver.com

Number8 Creative Inc.
www.number8creative.co.jp
7F Meguro G Bldg.
1-4-16 Meguro
Meguro-ku Tokyo 153-0063
Japan
Tel +81 50 5308 8460
info@number8creative.co.jp

Oregon State University
United States
junbum.shin@oregonstate.edu

Pentagram
www.pentagram.com
1508 W. 5th St.
Austin, TX 78703
United States
Tel +1 512 476 3076
design@texas.pentagram.com

Pirtle Design
www.pirtledesign.com
89 Church Hill Road
New Paltz, NY 12561
United States
woody@pirtledesign.com

Randy Clark
2801 Hollywood Drive
Arlington, TX 76013
United States
randyclarkmfa@icloud.com

Red Square
www.redsquareagency.com
54 Saint Emanuel St.
Mobile, AL 36602
United States
awards@redsquareagency.com

Rikke Hansen
awards@redsquareagency.com
Klovtoftvej 32
Roedding 6630
Denmark
Tel +45 23313560
rh@wheelsandwaves.dk

School of Visual Arts
220 E. 23 St., Suite 311
New York, NY 10010
United States
Tel +1 212 592 2380
vapress@sva.edu

Scott Laserow Posters
www.scottlaserowposters.com
1007 Serpentine Ln.
Wyncote, PA 19095
United States
Tel +1 215 576 0722
scott@zccreative.com

Shawn Meek & Sixto Juan-Zavala
4893 N Raleigh St.
Denver, CO 80212
United States
smeek3@msudenver.edu

Sol Bi Doo
Seoul
South Korea
sdoo0525@gmail.com

Sommese Design
100 Rose Drive Port
Matilda, PA 16870
United States
Tel +1 814 880 8143
lxs14@psu.edu

Stout SF
United States
Kelly.Mihalik@stoutsf.com

STUDIO INTERNATIONAL
Buconjiceva 43
Buconjiceva 43/III
Zagreb, HR-10 000 HR
CROATIA
Tel +385 1 37 60 171
 +385 98 276 932
boris@studio-international.com

studio lindhorst-emme
www.lindhorst-emme.de
Glogauer Str. 19.
studio lindhorst-emme,
1 Hinterhof links
Berlin, Berlin 10999
Germany
Tel +49 30 69564018
mail@lindhorst-emme.de

Studio Lonne Wennekendonk
Schiehavenkade 96-98
Rotterdam 3024
Netherlands
Tel +31 102449321
cindy@lonnewennekendonk.nl

Studio'farrell
www.instagram.com/tfxfarrell
United States
Tel +1 404 285 6551
tom@studiofarrell.com

SVIDesign
www.svidesign.com
242 Acklam Road, Studio 124
London, W10 5JJ
United Kingdom
Tel +44 207 524 7808
sasha@svidesign.com

WINNERS DIRECTORY

Takashi Akiyama Studio
3-14-35
Shimo-Ochiai
Shinjuku-ku, Tokyo 161-0033
Japan
Tel +81 3 3565 4316
akiyama@t3.rim.or.jp

The Pekoe Group
www.ThePekoeGroup.com
1160 Broadway, Floor 0
New York, NY 10036
United States
Tel +1 212 764 0890
christopher@thepekoegroup.com

THERE IS Studio
www.thereis.co.uk
London
United Kingdom
Tel +44 0 757 246 0707
eve@thereis.co.uk

TOKY Branding + Design
www.toky.com
3001 Locust, Second Floor
Saint Louis, MO 63103
United States
molly@toky.com

Tomaso Marcolla
www.marcolla.it
Lavis 38015
Italy
tomaso64@hotmail.com

Tsushima Design
www.tsushima-design.com
#401 Koyo bld, 13-22, Hacchoubori,
Naka-ku,
Hiroshima, Hiroshima 7300013
Japan
Tel +81 82 845 0372
info@tsushima-design.com

Underline Studio
247 Wallace Ave., 2nd Floor
Toronto, ON M6H 1V5
Canada
Tel +1 416 341 0475
kristin@underlinestudio.com

Ventress Design Works
www.ventress.com
6717 Rodney Ct.
Nashville, TN 37205
United States
Tel +1 615 833 2108
tom@ventress.com

Wesam Mazhar Haddad
www.wesamhaddad.com
Brooklyn, NY 11205
United States
haddadwesam@hotmail.com

Yinsen
www.yinsenstudio.com
Bonifaci Ferrer 5, 1°2
Valencia, Valencia 46007
Spain
Tel +34 629 060 181
info@yinsenstudio.com

Zulu Alpha Kilo
260 King Street E., Suite B101
Toronto, ON M5A 4L5
Canada
Tel +1 416 777 9858
awards@zulualphakilo.com

SILVER

Alex Seth
www.alexsethalex.com
4686 Woodside Drive, Apt. 306
Los Angeles, CA 90065
United States
Tel +1 323 217 3769
aseth@inside.artcenter.edu

AN kiyoung Design Room
www.facebook.com/ANkiyoung
KINDAI University (E-campus,A-2F),Sinkamiosaka 228-3,
Higashi-osaka Osaka 577-0813
Japan
Tel +81 90 9319 9396
aky6815@hotmail.com

Andrew Sloan
London
United Kingdom
Tel +44 7985 949 100
andysloan03@gmail.com

ARSONAL
www.arsonal.com
3524 Hayden Ave.
Culver City, CA 90232
United States
Tel +1 310 815 8824
cynthia@arsonal.com

Atelier Bundi AG
www.atelierbundi.ch
Schlossstrasse 78
Boll Berne CH-3067
Switzerland
Tel +41 31 981 00 55
bundi@atelierbundi.ch

Aufuldish & Warinner
www.aufwar.com
183 The Alameda
San Anselmo, CA 94960
United States
Tel +1 415 721 7921
bob@aufwar.com

BANKOVPOSTERS
www.bankovposters.com
Lipovska 465/6
Prague 15000
Czech Republic
Tel + 420 776102758
p.bankov@designdepot.ru

Behind the Amusement Park
www.behindtheamusementpark.com
Långa gatan 12
Stockholm, Stockholm 11521
Sweden
Tel +46 733 311 009
helene@b-t-a-p.com

Braley Design
www.braleydesign.com
3469 Lannette Ln.
Lexington, KY 40503
United States
Tel +1 415 706 2700
braley@braleydesign.com

CARLOS PION NEW YORK
www.carlospion.com
206 W. 17 St.
New York, NY 10011
United States
cpion@mac.com

Carmit Design Studio
2208 Bettina Ave.
Belmont, CA 94002
United States
Tel +1 650 283 1308
carmit@carmitdesign.com

Carter Hales Design Lab Inc.
www.carterhales.com
377 W. 6th Avenue
Vancouver, BC V5Y 1L1
Canada
Tel +1 604 630 5566
lab@carterhales.com

Charit Art Co., Ltd.
www.charitpusiri.com
415/1 Ladprao 107
Bangkapi, Bangkok 10240
Thailand
Tel +66 81 642 3922
airit.art@gmail.com

Cold Open
www.coldopen.com
1313 Innes Pl
Venice, California 90291
United States
Tel +1 310 399 3307
reception@coldopen.com

COLLINS
www.wearecollins.com
New York & San Francisco
United States
Tel +1 646 760 0800
info@wearecollins.com

DAEKI & JUN Studio
www.daekiandjun.com
3F, DAEKI & JUN Seoul
South Korea
Tel +82 (0)10 3104 0831
win.daekiandjun@gmail.com

Daisuke Kashiwa
www.kashiwadaisuke.net
Japan
kassy0105@gmail.com

Dalian RYCX Advertising Co., Ltd.
A6-12 No.419 Minzheng St.
Shahekou District
Dalian, Liaoning 116021
China
Tel +86 411 84519866
rycxcn@163.com

Dankook University
Room 317, College of Arts, Dankook University, 126,
Jukjeon, Suji Yongin Gyeonggi 448-701
South Korea
Tel +82 31 8005 3106
finvox3@naver.com

David Torrents
www.torrents.info
Mila I Fontanls
14, 2/2
Barcelona, Barcelona 08012
Spain
Tel +34 934 574 875
david@torrents.info

Dennard, Lacey & Associates
www.dennardlacey.com
13740 Midway Road, Suite 802
Dallas, TX 75244
United States
Tel +1 972 233 0430
james@dennardlacey.com

Design SubTerra
1590 Canyon Road
Providence, UT 84332
United States
Tel +1 435 753 0593
rain9@xmission.com

Dilara Sebnem Esendemir
www.dilarasebnem.com
Acibadem Cd No:33/8
Kadikoy, Istanbul
Turkey
Tel +90 534 363 06 49
info@monroeistanbul.com

DiMassimo Goldstein
ww.digobrands.com
220 E. 23rd St., Floor 2
New York, NY 10010
United States
Tel +1 212 253 7500
cevans@digobrands.com

Dizaino Studija Baklazanas
www.www.baklazanas.com
Lithuania
info@baklazanas.com

Dnkstudio
www.dnkstudio.com.ua
Pri Sajbach 32
Bratislava 83106
Slovakia
design@dnkstudio.com.ua

Doğan Arslan
Turkey
Tel +90 532 155 0779
doganaslan@yahoo.com

Eggra
Blvd. Kliment Ohridski No: 11/4
Skopje 10000
Macedonia
Tel +389 70389144
eggra.pars@gmail.com

Elephant In The Room
www.elephantintheroom.com
105 W. 4th St., 6th Floor
Winston-Salem, NC 27101
United States
Tel +1 336 287 3607
chad@elephantintheroom.com

Emerson, Wajdowicz Studios
www.designews.com
530 W. 25th St., Suite 301
New York, NY 10001
United States
Tel +1 212 807 8144
studio@designews.com

Estudio Pep Carrió
www.pepcarrio.com
C/ Génova, 11, 7°D
Madrid, Madrid 28004
Spain
Tel +34 913 080 668
info@pepcarrio.com

Eugene Lee
www.eugenes-sh.it
146 Hopper St.
New Jersey 07601
United States
Tel +1 201 575 3628
elee56@sva.edu

Exit10
www.exit10.com
323 W. Camden St., Floor 7
Baltimore, MD 21201
United States
Tel +1 443 573 8210
ehartsock@exit10.com

Faceout Studio
www.faceoutstudio.com
520 S.W. Powerhouse Drive, Suite 628
Bend, OR 97702
United States
Tel +1 541 323 3220
Torrey@faceoutstudio.com

Finn Nygaard
www.FinnNygaard.com
Strandvænget 62
Mors 7900
Denmark
Tel +45 4847 5310
fn@finnnygaard.com

Folkwang UdK
www.thomaskuehnen.de
Dorotheenstr. 2
Wuppertal, NRW 42105
Germany
Tel +49 (0)172 2557620
hallo@thomaskuehnen.de

Fons Hickmann m23
www.m23.de
Mariannenplatz 23
Berlin, Berlin 10997
Germany
Tel +49 3069518501
fons@m23.de

Sol Bi Doo
Seoul
South Korea
sdoo0525@gmail.com

Nihonbashi Mitsukoshi
www.chikako-oguma.com
1-10-22-1403 Nakameguro
Meguro-ku, Tokyo 153-0061
Japan
Tel +81 90 6045 2037
info@chikako-oguma.com

Gonca Koyuncu
Pınartepe Mah. Atatürk Cad.
Gürgen Sokak. Orkide Apt. No:17/3
Istanbul 34500
Turkey
Tel +90 5347 921 699
koyuncugonca@gmail.com

Gunter Rambow
www.gunter-rambow.com
Domplatz 16
Guestrow D-18273
Germany
GunterRambow@web.de

H. Tuncay Design
www.haluktuncay.com
Omer Rustu Pasa Sokak, Birlik, Apt.
26/8 Besiktas
Istanbul
Turkey
Tel +90 5325883747
haltuncay@gmail.com

HBO Latin America
396 Alhambra Circle, Suite 400
Coral Gables, FL 33134
United States
Tel +1 786 501 8318
dmichie@hbo-la.com

Henning Kreitel
Bessemerstr. 16
Berlin, Berlin 12103
Germany
h.kreitel@gmx.de

Hoyne
www.hoyne.com.au
Level 5, 99 Elizabeth St.
Sydney, NSW 2000
Australia
Tel +61 419290768
andrew@hoyne.com.au

hufax arts
www.facebook.com/HufaxArts
13F., No.17, Ln. 47, Sec. 1, Baofu Rd.,
Yonghe Dist.,
New Taipei City 23444
Taiwan
Tel +886 225 030 158
 +886 933 991 520)
hufa@ms12.hinet.net

Iconisus
www.iconisus.com
10000 Venice Blvd.
Culver City, CA 90232
United States
Tel +1 310 202 1600
sarit.snyder@fxnetworks.com

IF Studio
34 W. 27th St.
New York, NY 10001
United States
Tel +1 203 550 1432
toshi@ifstudiony.com

Ignition
United States
sarit.snyder@fxnetworks.com

imageon Co., LTD.
www.imageon.co.jp
1-10-2-501 Nishihara
Asaminami-Ku
Hiroshima-City, Hiroshima Pref.
7310113
Japan
Tel +81 82 846 1546
fukumoto@imageon.co.jp

Jie-Fei design
www.jiefeidesign.com
4F.,No.59,Tianmu E. Road
Shilin Dist., Taipei 11153
Taiwan
Tel +886 0955 875 579
jiefeidesign@gmail.com

João Machado Design
www.joaomachado.com
Rua Padre Xavier Coutinho, 125
Porto 4150-751
Portugal
Tel +351 226 103 772
geral@joaomachado.com

Justin Kemerling Design Co
www.justinkemerling.com
5416 Decatur St.
Omaha, NE 68104
United States
Tel +1 402 770 8657
hello@justinkemerling.com

Kari Piippo Oy
www.piippo.com/kari
Katajamäenkatu 14
Mikkeli 50170
Finland
Tel +358 15 162 187
kari@piippo.com

Kaveh Haerian
www.kavehhaerian.com
5731 Ridgedale Road
Baltimore, MD 21209
United States
kaveh.haerian@gmail.com

LaMachina Design Co.
2303 S. Michigan Ave., Unit. 505
Chicago, IL 60616
United States
Tel +1 312 972 3470
jpomared@yahoo.com

WINNERS DIRECTORY

Landor San Francisco
www.landor.com
110 Shillito Pl.
Cincinnati, OH 45202
United States
Tel +1 513 419 2345
thomas.hutchings@landor.com

Leo Lin Design
11F, No 64, 700th Lane,
Chung-Cheng Road
Hsintien, Taipei 231
Taiwan
Tel +886 2 8218 1446
leoposter@yahoo.com.tw

Leynivopnid
www.leynivopnid.is
Solvallagata 66
Reykjavik 101
Iceland
Tel +354 840 0220
einar@leynivopnid.is

Libido inc. & Linda Graphica
www.p-gallery-soco.com
7-17-14 Fukushima, Fukushima-ku
Osaka 553-0003
Japan
Tel +81 6 6458 1050
books@uran-dou.com

Magnus Gjoen
34 W. 27th St.
New York, NY 10001
United States
Tel +1 203 550 1432
toshi@ifstudiony.com

Marcos Minini
www.marcosminini.com
Rua Wellington de Oliveira Viana
70 / 408
Curitiba, PR 80530-350
Brazil
Tel +55 41 9971 0860
mminini@uol.com.br

Markham & Stein
www.markhamandstein.com
527 Holiday Drive
Hallandale Beach, FL 33009
United States
jackbagdadi@hotmail.com

Martin French Studio
www.martinfrench.com
511 N.W. Broadway
Portland, OR 97209
United States
Tel +1 503 926 2809
studio@martinfrench.com

MAT
www.matistanbul.net
Cihangir Caddesi
38/3, Cihangir
Beyoğlu, Istanbul 34433
Turkey
Tel +90 532 292 38 57
mat@matistanbul.net

Mazzarium Inc.
www.mazzarium.com
3016 Alcazar Drive
Burlingame, CA 94010
United States
Tel +1 650 270 8408
mazzarium@gmail.com

McCandliss and Campbell
www.mccandlissandcampbell.com
135 W. 20th St., Suite 402
New York, NY 10011
United States
Tel +1 917 326 1843
mcandcstudio@gmail.com

Meaghan A. Dee
www.meaghand.com
Blacksburg, VA 24061
United States
Tel +1 541 632 4426
meaghan.dee@gmail.com

Michael Schwab Studio
108 Tamalpais Ave.
San Anselmo, CA 94960
United States
Tel +1 415 257 5792
studio@michaelschwab.com

Molly Tuttle Design
www.mollytuttledesign.com
2028 Rosilla Pl.
Los Angeles, CA 90046
United States
Tel +1 415 686 4663
molly@mollytuttledesign.com

Monroe Creative Studio
www.monroeistanbul.com
Kulo lu Mh. Güllabici Sk. Venti Ap.
No: 20/2 Cihangir
Beyoglu, Istanbul 34434
Turkey
Tel +90 212 243 78 04
info@monroeistanbul.com

NICE CREATIVE
blog.sina.com.cn/huangyongdesigin
2502 room, Block B, Starfish City
Square, #37, Keji Road, Hi-tech Zone
Xi'an City, Shaanxi Province
China
Tel +86 18729525726
huangyongdesign@163.com

Norikyuki Kasai
Lexel Garden Makuhari209, 5-417-325
Makuhari-cho, Hanamigwa-ku
Chiba-city, Chiba 262-0032
Japan
Tel +81 43 351 5033
kasai.noriyuki@nihon-u.ac.jp

OGAWAYOUHEI DESIGN DESK
4-1-3 Kyutaro cho, Chuo-ku
Osaka
Japan
Tel +81(6)6282 7783
ogawayouhei.dd@gmail.com

Oncetudio
www.huangyaoyao.com
No.88 Daxue Road, Ouhai District
Wenzhou City, Zhejiang Province
325060
China
Tel +86 18324246868
hyao@kean.edu

Osborne Ross
www.osborneross.com
The Courtyard 4 Evelyn Road
Chiswick, London W4 5JL
United Kingdom
Tel +44 (0)20 8742 7227
andrew@osborneross.com

OUWN
www.ouwn.jp
Kubo Bldg. 501
1-7-4 Ohashi
Meguro-ku, Tokyo 153-0044
Japan
info@ouwn.jp

Owen Gildersleeve Ltd.
www.owengildersleeve.com
23 - 27 Arcola St., Studio F12
London E8 2DJ
United Kingdom
hello@owengildersleeve.com

Penrose 300
www.tyler.temple.edu/programs/
graphic-interactive-design
Tyler School of Art, 2001 N. 13th St.
Philadelphia, PA 19122
United States
Tel +1 215 621 6559
kholohan@temple.edu

Pentagram
www.pentagram.com
1508 W. 5th St.
Austin, TX 78703
United States
Tel +1 512 476 3076
design@texas.pentagram.com

Petrol Advertising
443 N. Varney St.
Burbank, CA 91502
United States
Tel +1 323 644 3720
artr@petrolad.com

Pivot Design
www.pivotdesign.com
321 N. Clark St., Suite 600
Chicago, IL 60654
United States
Tel +1 312 787 7707
kathryn@pivotdesign.com

Purdue University
3816 Capilano W. Drive
W. Lafayette, IN 47906
United States
Tel +1 765 543 7728
sigman@purdue.edu

Randy Clark
2801 Hollywood Drive
Arlington, TX 76013
United States
randyclarkmfa@icloud.com

Rikke Hansen
www.wheelsandwaves.dk
Klovtoftvej 32
Roedding 6630
Denmark
Tel +45 23313560
rh@wheelsandwaves.dk

Rose
www.rosedesign.co.uk
The Old School
70 St. Marychurch St.
London SE16 4HZ
UNITED KINGDOM
hello@rosedesign.co.uk

Ryan Russell Design
195 Brynwood Drive Port
Matilda, PA 16870
United States
Tel +1 814 880 6377
rer190@psu.edu

Sandstrom Partners
www.sandstrompartners.com
808 S.W. 3rd, #610
Portland, OR 97204
United States
Tel +1 503 248 9466
stacy@sandstrompartners.com

Savannah College of Art and Design
www.scad.edu
115 E. York St.
Savannah, GA 31402
United States
sward@scad.edu

School of Visual Arts
220 E. 23 St., Suite 311
New York, NY 10010
United States
Tel +1 212 592 2380
vapress@sva.edu

Selman Design
www.selmandesign.com
19 Fulton St., #307
New York, NY 10038
United States
212 571 0489
johnny@selmandesign.com

Sommese Design
100 Rose Drive Port
Matilda, PA 16870
United States
Tel +1 814 880 8143
lxs14@psu.edu

Stavitsky Design
www.stavitsky.ru
Chelabinskaya St., 6, 350
Moscow 105568
Russia
Tel +7 965 257 77 26
stavitsky1@yandex.ru

Steiner Graphics
www.renesteiner.com
155 Dalhousie St., Suite 1062
Toronto, ON M5B 2P7
Canada
Tel +1 416 792 6969
rene@steinergraphics.com

Stephen Guenther
www.stephenguenther.com
1414 Hinman 1b
Evanston, IL 60201
United States
Tel +1 847 732 2291
stephen.guenther@gmail.com

Studio Cuculi
www.studio-cuculic.hr
Petrova 51
Zagreb 10000
Croatia
ana@studio-cuculic.hr

Studio Geray Gencer
www.geraygencer.com
19 Mayıs Cad. Golden Plaza No:1
Kat: 10
i li Istanbul, 34360
Turkey
Tel +90 533 630 87 84
geraygencer@yahoo.com

Studio Lindhorst-emme
www.lindhorst-emme.de
Glogauer Str. 19.
studio lindhorst-emme,
1 Hinterhof links
Berlin, Berlin 10999
Germany
Tel +49 30 69564018
mail@lindhorst-emme.de

Studio Lonne Wennekendonk
Schiehavenkade 96-98
Rotterdam 3024
Netherlands
Tel +31 102449321
cindy@lonnewennekendonk.nl

studioKALEIDO
www.studiokaleido.net
Blk 3 Delta Ave., #12-36
Singapore, Singapore 160003
SINGAPORE
winnie@studiokaleido.net

Superunion
United Kingdom
miki@the-partners.com

SVIDesign
www.svidesign.com
242 Acklam Road, Studio 124
London W10 5JJ
UNITED KINGDOM
Tel +44 2075247808
sasha@svidesign.com

Takashi Akiyama Studio
3-14-35
Shimo-Ochiai
Shinjuku-ku, Tokyo 161-0033
Japan
Tel +81 3 3565 4316
akiyama@t3.rim.or.jp

Ted Wright Illustration & Design
1705 N. Woodlawn Ave.
Ladue, MO 63124
United States
twrightart@aol.com

Tetsuro Minorikawa
www.minorikawa.net
Nagaoka Institute of Design
4-197 Senshu
Nagaoka, Niigata 940-2088
Japan
Tel +81 90 5441 9646
info@minorikawa.net

The Pekoe Group
www.ThePekoeGroup.com
1460 Broadway, Floor 8
New York, NY 10036
United States
Tel +1 212 764 0090
christopher@thepekoegroup.com

TOKY Branding + Design
www.toky.com
3001 Locust, Second Floor
Saint Louis, MO 63103
United States
molly@toky.com

Toyotsugu Itoh Design Office
www.facebook.com/toyotsuguoffice
402 Royal Villa Tsurumai
4-17-8 Tsurumai,Showa-ku
Nagoya, Aichi Prefecture 466-0064
Japan
Tel +81 52 731 9747
toyo-ito@ya2.so-net.ne.jp

TracyLocke
1999 Bryan St., Suite 2800
Dallas, TX 75201
United States
glen.day@tracylocke.com

Venti caratteruzzi
www.venticaratteruzzi.com
Principe di Villafranca, 83
Palermo 90141
Italy
Tel +39 0919820530
carlo@venticaratteruzzi.com

VEX Robotics in-house studio
6725 W. FM 1570
Greenville, Texas 75402
United States
Tel +1 903 453 0843
brian@vex.com

Warkulwiz Design Associates
www.warkulwiz.com
89 E. Wynnewood Road
Merion Station, PA 19066
United States
Tel +1 215 988 1777
bob@warkulwiz.com

Woosuk University
SOUTH KOREA
Tel +82 43 531 2806
mijung6@nate.com

Yohei Takahashi
www.yoheitakahashi.com
3-14-26-A-301
Shimoochiai
Shinjuku-ku Tokyo 161-0033
Japan
yohhey219@gmail.com

Zulu Alpha Kilo
260 King Street E., Suite B101
Toronto, ON M5A 4L5
Canada
Tel +1 416 777 9858
awards@zulualphakilo.com

WINNERS BY COUNTRY

Throughout time the poster has stood as an enduring reflection of the moment it was designed. This year's Graphis archive is no exception, for it too will serve the future practitioner as a record of the early 21st century poster.

Rick Valicenti, Founder & Design Director, Thirst

BEST IN THE AMERICAS

BRAZIL
Angry Dog 91
Marcos Minini 193

CANADA
Carter Hales Design Lab Inc. 83, 84, 175
Steiner Graphics 191
Underline Studio 43, 44
Zulu Alpha Kilo 38, 158

USA
21xdesign 33
Alex Seth 197
ARSONAL 52, 57, 161-163
Aufuldish & Warinner 158, 183
Braley Design 60, 92, 99, 114, 138, 164-166, 191, 192
CARLOS PION NEW YORK 198
Carmit Design Studio 117, 150, 182, 198
Cold Open 56, 160, 161, 163
COLLINS 31, 184
Dennard, Lacey & Associates 195
Design SubTerra 168, 179
DiMassimo Goldstein 185
Elephant In The Room 176
Emerson, Wajdowicz Studios 169
Eugene Lee 172
Exit10 171
Faceout Studio 187
FleishmanHillard 116
FX Networks/Bond/P+A/Ignition/
Iconisus 34
Gravdahl Design 42, 127
HBO Latin America 162
Iconisus 34, 193
IF Studio 122, 123, 187, 188, 192
Ignition 34, 192
InSync PLUS 53-55
Jeremy Honea 49
Justin Kemerling Design Co 189
Kaveh Haerian 178
Landor San Francisco 185, 197
Langrand 147, 149
LaMachina Design Co. 176
Magnus Gjoen 192
Markham & Stein 157
Marlena Buczek Smith 129, 139
Martin French Studio 178
Mazzarium Inc. 186
McCandliss and Campbell 183
Meaghan A. Dee 196
Michael Schwab Studio 165
Molly Tuttle Design 178
Oregon State University 133
Penrose 300 166
Pentagram 61, 128, 169
Petrol Advertising 160, 163
Pirtle Design 75
Pivot Design 188
Purdue University 159
Randy Clark 74, 79, 172
Red Square 111
Ryan Russell Design 190
Sandstrom Partners 174
Savannah College of Art and Design 174, 175
School of Visual Arts 107, 108, 172, 183, 185
Scott Laserow Posters 58
Selman Design 168
Shawn Meek & Sixto Juan Zavala 81
Sommese Design 70, 166
Stephen Guenther 197
Stout SF 46, 47, 152
Studio'farrell 132
Ted Wright Illustration & Design 162, 167, 177
The Pekoe Group 146, 197
TOKY Branding + Design 62, 151, 169
Traction Factory 32
TracyLocke 156
Ventress Design Works 90
VEX Robotics in-house studio 159
Warkulwiz Design Associates 157
Wesam Mazhar Haddad 140

BEST IN EUROPE & AFRICA

CROATIA
Studio Cuculić 194
STUDIO INTERNATIONAL 126

CZECH REPUBLIC
BANKOVPOSTERS 175

DENMARK
Finn Nygaard 173
Rikke Hansen 26, 135, 164

FINLAND
Kari Piippo Oy 45, 157, 189

GERMANY
Ariane Spanier Design 94, 102
Elsenbach Design 93
Folkwang UdK 198
Fons Hickmann m23 69, 98, 171, 190
Gunter Rambow 30, 71, 72, 103, 104, 106, 180, 181
Henning Kreitel 177
studio lindhorst-emme 96, 170

ITALY
Tomaso Marcolla 134
Venti caratteruzzi 179, 180

LITHUANIA
Dizaino Studija Baklazanas 156

MACEDONIA
Eggra 194

THE NETHERLANDS
Studio Lonne Wennekendonk 89, 194

PORTUGAL
João Machado Design 77, 87, 95, 110, 158, 173, 174, 177

RUSSIA
Stavitsky Design 167

SLOVAKIA
Dnkstudio 125, 192

SPAIN
David Torrents 170
Estudio Pep Carrió 59, 112, 158, 175
Husmee 41, 88
Yinsen 67

SWEDEN
Behind the Amusement Park ... 113, 182

SWITZERLAND
Atelier Bundi AG 105, 131, 143, 145, 148, 156, 194
hofmann.to 27
Melchior Imboden 78, 97

UNITED KINGDOM
Andrew Sloan 190
Osborne Ross 184
Owen Gildersleeve Ltd. 179
Rose 181
Superunion 164
SVIDesign 40, 178
THERE IS Studio 100, 101

BEST IN ASIA & OCEANIA

AUSTRALIA
Hoyne 118-121, 124, 187, 188

CHINA
Dalian RYCX Advertising Co., Ltd. 165, 191
NICE CREATIVE 186
Oncetudio 184

ISRAEL
Leynivopnid 182

JAPAN
AN kiyoung Design Room 159
Daisuke Kashiwa 164, 171
Graphic Art Seminar Laboratory 48, 51, 159
imageon Co., LTD. 165, 184
KINDAI university 51, 159
Libido inc. & Linda Graphica 171
Nihonbashi Mitsukoshi 167
Norikyuki Kasai 170
Number8 Creative Inc. 137
OGAWAYOUHEI DESIGN DESK ... 193, 195
OUWN 157
Takashi Akiyama Studio 29, 50, 63, 76, 159
Tetsuro Minorikawa 181
Toyotsugu Itoh Design Office 189
Tsushima Design 73, 136
Yohei Takahashi 190

KOREA
DAEKI & JUN Studio 64, 109, 185, 186
Dankook University 80, 189
HYUK-JUNE JANG 39
Namseoul University 115
Sol Bi Doo 141
Woosuk University 170, 183

NEW ZEALAND
Alt Group 65, 66

SINGAPORE
studioKALEIDO 168

TAIWAN
hufax arts 198
hufax arts Co., Ltd. / C.U.T.e 28, 153
Jie-Fei Design 173
Leo Lin Design 172

THAILAND
Charit Art Co., Ltd. 176

TURKEY
Begum Gucuk 130
Dilara Sebnem Esendemir 173
Doğan Arslan 174
Gonca Koyuncu 168
H. Tuncay Design 142, 144, 193
MAT 82, 172
Monroe Creative Studio 85, 86, 156, 179
Studio Geray Gencer 186

Graphis Exhibitions

Graphis invites you and your club to join our Exhibition Program.

For only $97 annually, you can receive the following:

1. Four issues of the Graphis Journal.

2. One Graphis Annual of your choice.

 A $230 value for only $97.

Here's what you and your club can potentially receive:

1. Two to four international exhibitions brought to your club annually.

2. No need to travel for shows, saving you hotel and transportation costs.

3. Free entry to these Graphis exhibitions.

4. Presentation of the best work from your club's members at the shows.

5. Help with increasing your membership.

6. Income to your club from non-member entry fees.

What Graphis will need:

A reasonable percentage of your members to join for just $97 each.

Visit www.graphis.com for more information.

Graphis Poster Annual 2019
PLATINUM & GOLD AWARD-WINNING WORK

Graphis Poster Annual 2018
PLATINUM & GOLD AWARD-WINNING WORK

Graphis Titles

Typography 4

2018
Hardcover: 256 pages
200-plus color illustrations
Trim: 8.5 x 11.75"
ISBN: 978-1-931241-68-7
US $90

Awards: This year, Graphis awarded 18 Platinum, 150 Gold, 219 Silver, and 116 Merit Awards, totaling over 500 winners.
Platinum Winners: ARSONAL, Chemi Montes, DAEKI & JUN, Hufax Arts, Jones Knowles Ritchie, McCandliss & Campbell, Ron Taft Design, SCAD, Selman Design, Studio 32 North, Traction Factory, Umut Altintas, Atlas, Jamie Clarke Type, Jones Knowles Ritchie, Linotype, SVA, and Söderhavet.
Judges: Entries were judged by highly accomplished Type Designers: Nadine Chahine (LB), Akira Kobayashi (JP), and Dan Rhatigan (US).
Editorial: A documentation of the history of typeface design from the 5th Century B.C. to 2018, as well as informative articles on Typeface Design Masters Matthew Carter and Ed Benguiat.

Photography Annual 2018

2018
Hardcover: 256 pages
200-plus color illustrations
Trim: 8.5 x 11.75"
ISBN: 978-1-931241-66-3
US $90

This year's Platinum Award-winning Photographers are **Athena Azevedo**, **Athena Azevedo**, **Ricardo de Vicq de Cumptich**, **Tim Flach**, **Bjorn Iooss**, **Parish Kohanim**, **Gregory Reid**, **Mark Seliger**, **Adam Voorhes**, and **Dan Winters**. Work was judged by a panel of award-winning Photographers, all of whom are Graphis Masters: Craig Cutler, Parish Kohanim, RJ Muna, and Lennette Newell. Also presented is an In Memoriam feature on Graphis Master Photographer Pete Turner, which includes his biography and some of his most extraordinary photographs. As always, a list of international photography museums is also presented. This Annual is a valuable resource for Photographers, Design Firms, Advertising Agencies, Museums, students, and Photography enthusiasts.

New Talent Annual 2018

2018
Hardcover: 256 pages
200-plus color illustrations
Trim: 8.5 x 11.75"
ISBN: 978-1-931241-65-6
US $90

This year's panel of Judges awarded over 1,000 winners. Platinum-winning Instructors are: Advertising: **Frank Anselmo**, **Indrajeet Chandrachud**, **Seung-Min Han**, **Patrik Hartmann**, **Robert Mackall**, **Jack Mariucci**, **Dong-Joo Park**, and **Mel White**; Design: **Sean Adams**, **Peter Ahlberg**, **Chris Austopchuk**, **Chris Hacker**, **Seung-Min Han**, **Eileen Hedy Schultz**, **Tyler Hopf**, **Dong-Joo Park**, and **Adrian Pulfer**; Photography: **Lynda Green**; and Film: **Ori Kleiner**, **Marcos Lawson**, **Hye Sung Park**, **Mark Smith**, and **Myoung Zin Won**. Platinum and Gold Winners receive full-page presentations. Silver Winners are also presented, and Merits are listed. Education Master Phillip Becker is featured in honor of his retirement. This book can be an invaluable resource for Instructors and students.

Advertising Annual 2018

2018
Hardcover: 256 pages
200-plus color illustrations
Trim: 8.5 x 11.75"
ISBN: 978-1-931241-64-9
US $90

Graphis presents this year's Platinum Winners: **50,000feet**, **ARSONAL**, **Butler, Shine, Stern & Partners**, **Cold Open**, **CP+B**, **CP+B London**, **designory.**, **Greenhaus**, **Grupo daDá**, **MMB**, **Ogilvy Germany**, **PPK**, **USA**, **Saatchi & Saatchi Wellness**, **Schifino Lee**, **The&Partnership**, **Traction Factory**, **Van Winkle + Associates**, **xose teiga, studio**, and **Zulu Alpha Kilo**. Platinum and Gold Winners receive full-page presentations of their work. Silver and Merit Award-winning work is also presented. Entries were scored by award-winning judges: Kathy Delaney, Keith Ireland, Nick Bontaites, Kim Tarlo, Pam Patterson, and Barney Goldberg. Also featured is an In Memoriam for David Swartz of CP+B, and Platinum-winning work from Professors and Students in New Talent Annual 2017 and 2016.

Design Annual 2018

2017
Hardcover: 256 pages
200-plus color illustrations
Trim: 8.5 x 11.75"
ISBN: 978-1-931241-61-8
US $120

IF Studio, **ARSONAL**, **Bruce Mau Design**, **Michael Pantuso Design**, **Shotopop**, **PepsiCo Design & Innovation**, and **Studio A** are this year's Platinum Winners. The international panel of Judges, Award-winning Designers **Kit Hinrichs**, **Gunter Rambow**, **Andrea Castelletti**, **Álvaro Pérez**, **Eduardo Aires**, **Boris Ljubicic**, **Tosh Hall**, **Trevett McCandliss**, and **Nancy Campbell**, each provided their scores and commentary on the work, which resulted in 7 Platinum, 125 Gold, 346 Silver, and 272 Merit Winners. Also included is student work inspired by talented Professors from the 2016 and 2017 New Talent Annuals. An extensive list of international design museums is also included. This Annual is a resource for Designers, Art Directors, Clients, Museums, and Design enthusiasts.

Takenobu Igarashi

2018
Hardcover: 304 pages
400-plus color illustrations
Trim: 10 x 14"
ISBN: 978-1-931241-63-2
US $70

Chronicling the career of the award-winning Japanese graphic designer, industrial designer, and fine artist Takenobu Igarashi—the subject of Takenobu Igarashi: Design and Fine Art—is a fast-paced and colorful adventure through time, space, and geography.
Igarashi won acclaim in the 1970s as a graphic designer for his axonometric alphabets, successfully extended his vision in the 1980s to include product design, and concluded 25 years of design activity in the 1990s by becoming a sculptor.
Takenobu Igarashi: Design and Fine Art presents a richly illustrated and carefully documented survey of Igarashi's career and work which features over 400 striking images and a revealing text translated from the original Japanese by Naoko Metzler-Nakayama.

Books are available at www.graphis.com/store

www.Graphis.com